IMAGES
of America

HOKE COUNTY

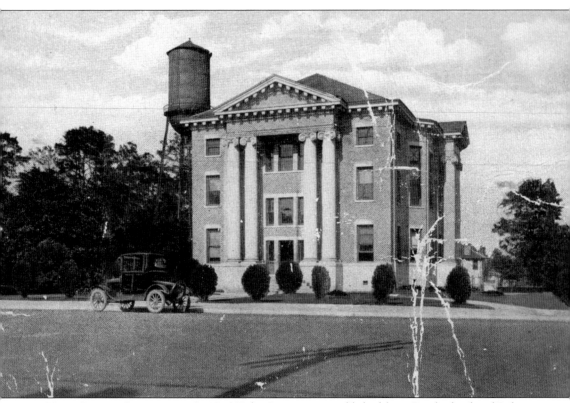

HOKE COUNTY COURTHOUSE. In 1911, Hoke County was established from Cumberland and Robeson Counties and the newly formed county commissioners hired Milburn and Heister of Washington, D. C., to design a courthouse. They issued bonds of $57,000 to finance its construction. J. A. Jones of Charlotte was the contractor for the building, which was completed in 1912 and is still in use today. (Courtesy of Raeford-Hoke Museum.)

ON THE COVER: HOKE DRUG COMPANY. In 1911, the McPherson Brothers Drug Company opened the drugstore in Raeford. Walter Baker bought the business in 1924. He was a charter member of the Raeford Kiwanis Club, a Mason, and a Shriner. Baker was chairman of the Democratic Executive Committee for 14 years and a director of the Raeford Savings and Loan Association. (Courtesy of Phyllis Baker McNeill.)

IMAGES
of America

HOKE COUNTY

Joyce C. Monroe and
the Raeford-Hoke Museum

Joyce C Monroe

ARCADIA
PUBLISHING

Published by Arcadia Publishing
Charleston, South Carolina

Printed in the United States of America

Library of Congress Control Number: 2010929187

For all general information, please contact Arcadia Publishing:
Telephone 843-853-2070
Fax 843-853-0044
E-mail sales@arcadiapublishing.com
For customer service and orders:
Toll-Free 1-888-313-2665

Visit us on the Internet at www.arcadiapublishing.com

CONTENTS

ACKNOWLEDGMENTS

The Raeford-Hoke Museum book committee would like to thank many people who have provided pictures, information, and stories to make this book possible.

The book committee members are Joyce C. Monroe, Mary Neil King, Locke MacDonald, Delia McNeill, Connie F. Ellis, Kermit Wood Jr., Elvenia Southerland, Lynette Dial, Anna Garrison, Ellen McNeill, and Jim Sinclair.

First we would like to thank Ken MacDonald, editor of the *News-Journal*, for allowing us to research the newspaper archives. A special thank you goes to Jim Sinclair who traveled several times from Raleigh, North Carolina, to donate and identify pictures. To Connie F. Ellis and Delia McNeill, who spent many hours correcting the manuscript, we offer a very special thank you.

We would like to thank our families who have been patient and understanding about late lunches and supported us as we worked. The list of people who have helped in many ways appears here in alphabetical order according to first names: Alice M. Stanback, Alona McNeill, Anne Gore Register, Chandler Roberts, Charles Heath, David Willis, Dodie Currie, Don Conoly, Edith Newton, Elizabeth Parker McPherson, Elizabeth Webb, Ellen K. Parker, Josh Scull, Hoke County Library, Jim Sinclair, Jennie Bethune, Judy Strother, Lib Wilson, Louise McDiarmid, Kermit Wood Jr., Luke McNeill, Mary Kate Posey, Mike Hoffman, Norma Strother, North Carolina Collection at the University of North Carolina Library at Chapel Hill, Phyllis Baker McNeill, Richard Neeley, Stephen Pate, Virginia Monroe McColl, and William T. Niven. Charles Heath, director of the U.S. Army Fort Bragg Cultural Resources Management program provided pictures and stories about early days of Fort Bragg, North Carolina. A special thanks goes to Lindsay Harris who kept a check on us and gave good advice.

Unless otherwise noted all images appear courtesy of the *News-Journal*.

INTRODUCTION

Hoke County, the 99th of 100 counties in North Carolina, lies within two hypsographic regions: the Carolina Georgia Sandhills and the Southern Coastal Plain. Its most remarkable geographic features are the Carolina bays ranging from southeastern North Carolina to northeastern Georgia. They vary in size from less than 1 acre to more than a 1,000. Prior to colonization, Tuscarora Indians inhabited the region.

For the purpose of this book, the Raeford-Hoke story begins with two gentlemen who operated a turpentine distillery and general store near the old swimming hole on Rockfish Creek. Turpentine and lumber were the leading businesses at the time. Needing a post office in this vicinity and a name for it, John McRae and A. A. Williford combined parts of their own names resulting in a "Raeford" postal service, which opened in the early 1890s.

Another aspect to the unfolding story came in 1895 with the building of a college preparatory facility, the Raeford Institute. The families of A. P. Dickson, J. W. McLauchlin, and John McRae were instrumental in beginning the school. Rare for its time, the school served as a real draw for farming families looking for educational opportunities for their children.

Education and religion were driving forces behind the growth of the area, and by 1904, the institute was circled by churches—the Presbyterians were due west, the Methodists to the east, and the Baptists to the north. The Presbyterian churches of Bethel, Sandy Grove, and Galatia had already been in existence for many years. Bethel, the oldest active church in the county, dates back to 1776. Long Street Church was established even earlier, in 1758, but because of its location in the Fort Bragg Reservation, it is no longer active.

African American churches had also been on the scene for some time: Freedom Chapel AME Zion Church, 1865; Bridges Grove AME Zion Church, 1873; and Walls Chapel United Methodist Church, 1874. Mount Elim, the oldest Native American church, was founded in 1924.

Raeford was chartered in 1901 with a main street 80 feet wide so that a two-horse wagon and team could turn around without having to go backward. For many years, a well was located in the middle of this road at the intersection of Raeford's two most prominent roadways, Main Street and Central Avenue. Its town limits were exactly three quarters of a mile in all directions from this point. The town's population was composed of many people who had moved here because of the institute. The abundance of churches was both a reason for and a by-product of this town and its people.

By 1899, John Blue's Aberdeen and Rockfish Railroad had extended its line into the Raeford area, and a train station was added in 1918. The Bank of Raeford began in 1903; it was one of the few banks to remain open during the Great Depression and is still in operation as Branch Banking and Trust Company. All these factors set the stage for the substantial growth and change to occur in the next decade.

The field of medicine was also well represented in the county's history. Dr. Hector McLean began the Edenborough Medical College in 1867, the first chartered in the state. A few miles

to the west, McCain Sanatorium opened in 1907 where 1,000 acres had been set aside for the treatment of all forms of tuberculosis. It was the only medical facility of its kind for children, and only the third tuberculosis sanatorium in the entire nation.

J. W. McLauchlin opened the first turpentine still in 1890. W. J. Upchurch and T. B. Upchurch opened the first sawmill in 1896, followed by a cotton mill in 1907 and a power plant near Rockfish. A milling company was operated first at the cotton mill, and in 1916 it became a separate business, the Upchurch Milling Company. An oil mill opened in 1912, as well as a lumber company in 1920.

Facts and Figures, the area's first newspaper, was started in 1905 by D. Scott Poole. It later became the *Hoke County Journal* and subsequently consolidated with another paper that opened in 1928, the *Hoke County News*. The owner of the business, Paul Dickson, formed the newspaper his family still runs today, the *News-Journal*.

It is not surprising that with all this development, in 1911 the county of Hoke—named for the North Carolina native and Confederate general Robert F. Hoke—was carved from parts of Cumberland and Robeson Counties, with Raeford as its county seat. One of the first orders of business was to construct a two-story courthouse in the neoclassical revival style. It opened in 1912 and is still in use today.

McLauchlin was instrumental in the formation of this new county, and he has become known as the "Father of Hoke County." Fittingly, his home serves as the Raeford-Hoke Museum.

McLauchlin, a state senator from Cumberland County, lived only 4 miles from the present Hoke County Courthouse. Twice, he and others had pushed for legislation to make this sparsely populated area a separate county. Both efforts failed, but the third attempt was successful when the name "Hoke" was proposed.

Hoke, much beloved by his home state, served the Confederacy during the Civil War with distinction and heroism. Many North Carolina soldiers served in his ranks and bestowing him this honor was politically popular at the time.

The county initially contained 268,000 acres with a population of around 10,000. No paved roads existed, and its economy was becoming agricultural. The population consisted predominantly of Highland Scots (explaining the many Presbyterian churches), African Americans, and, after World War II, Lumbee Indians.

The first elected county officials were W. B. McQueen, clerk of court; J. Hector Smith, register of deeds; Edgar Hall, sheriff; W. J. McCraney, treasurer; J. L. McFadyen, surveyor; A. P. Dickson, coroner; J. W. Johnson, S. J. Cameron, and J. A. McPhaul, commissioners; J. A. McGoogan, superintendent of education; N. A. McDonald, John A. Hodgin, and Neill McKinnon, board of education; J. W. Currie, county attorney; J. W. Johnson, state senator; and Thomas McBryde, state representative.

Change came swiftly to the area in the early part of the 20th century, and even more was on the horizon for this fledgling county. Because of an abundant water supply, convenient rail facilities, and pleasant climate, the federal government established Camp Bragg as a field artillery site just north of Hoke County in 1918. Four years later, by congressional law, it became Fort Bragg—an action that would have both immediate and long-term impact on the county.

The military base soon expanded by annexing 92,000 acres from the northern part of Hoke County. As a result, Little River Township of Hoke was cut off by the army reservation and in 1958 transferred to Moore County. Hoke County was left with 150,000 acres.

In 1952, when the army planned to acquire an additional 49,000 acres of Hoke land, a committee of citizens went to Washington, D.C., to campaign against further annexation. With much citizen support, J. Lawrence McNeill, C. L. Thomas, H. A. Greene, Robert H. Gatlin, N. H. G. Balfour, and Paul Dickson Jr. were successful, and the military spared Hoke, taking 3,000 acres from Cumberland County instead.

By their proximity and patriotism, the people of Hoke have always had close ties with the military. The county was only six years old when the United States entered World War I. Four hundred of its citizens went into service, mostly with the 81st Infantry Division, also known as

the "Wildcat Division," or the 42nd Infantry Division, known as the "Rainbow Division."

During World War II, the 252d Regiment of Coast Artillery National Guard from Hoke entered the war full-strength, supplying 165 men and 10 officers.

For decades, the military installations of Fort Bragg, Camp MacKall, and the Maxton-Laurinburg Air Base have populated Hoke County with large numbers of military personnel and their families, a trend that continues today.

In 1925, a fire devastated parts of downtown Raeford. A volunteer fire department was formed, the beginning of a tradition that is still in effect. Today each community in the county has its own fire station, which is manned by citizen volunteers.

Education continued to be important to the people of Hoke County. A high school was built at Antioch in 1911, and in 1912 the Raeford Public High School took the place of the Raeford Institute. By this time, there were a dozen one-room, single-teacher schools scattered across the county. A four-month term was compulsory for all children between the ages of eight and 12.

A public library opened in 1934. Before a separate building could be secured, patrons used the room above Reaves Drug Store (later called Howell Drug Company.)

By the 1950s, there were four graded schools and one high school for Caucasians, one school for Native Americans, and four elementary and one high school for African Americans. With the coming of integration in the 1960s, all races were consolidated.

Turpentine and timber industries gave way to cotton and tobacco. Later grain farming, along with raising hogs and cattle, became new sources of income for farmers. Para Thread and Robbins Mill opened up in the 1950s, bringing a new dimension to the industrial scene.

In the following decade, Hoke County boasted three cotton gins, Upchurch Milling, Hoke Concrete Works, Hoke Oil and Fertilizer Company, Raeford Lumber Company, Raeford Lumber Company Sawmill, F. P. Johnson's Corn Mill, U.S. Rubber Company, and Priebe Poultry, which later became known as the House of Raeford. Burlington Industries was the world's largest worsted manufacturing plant of the time.

Now, as Hoke County celebrates its centennial, it is once again poised for growth and change. With the realignment of military bases and Fort Bragg set to become the largest military complex in the world, the county has become one of the fastest growing areas in North Carolina. The 2000 Census reported the population at around 34,000, and now just a decade later, it is more than 45,000.

Horse farming is a growing trend in western Hoke County. The abundance of longleaf pine makes the area one of the state's leaders in pine straw production. Tarheel Hatchery and House of Raeford are leaders in poultry production and both are reasons for Hoke's annual North Carolina Turkey Festival. Burlington Industries and Unilever are still strong contributors to the economy, as well as Hoke county schools, which provide employment for hundreds.

Yes, the future of Hoke County promises great change once again. May what transpires be a credit to the people of this county and those who have made its history.

HOKE COUNTY
(AUTHOR UNKNOWN)

When you pass through North Carolina,
The Old North State, there's nothing finer,
Just take a look when you pass through Hoke,
No better county, then you spoke.
We are learning to walk at rapid rate,
And proving to the passers by each year
That we're wide-awake, going in high gear.

You'll view no farms while passing through-
That'll beat Hoke County, this is broad but true.
No finer cotton or tobacco is made,
We farm scientifically, it has always paid.
We've got the folks and we've got the soil,
We get result through honest toil.
We boast this section is one of the best,
It can be proven, this is no jest.

Hard surfaced roads or smooth, sandy clay,
Make motoring easy, they are here to stay.
Our schools are modern in every respect;
Children are examined for every defect.
Their eyes are looked after, their teeth and chest.
And they are taught what to eat for their health that is best.
We've fruits and vegetables and streams for fish,
And a climate to satisfy every wish.

You may call us a baby or other pet name.
But nineteen eleven, proved we were game.
Our dreams came true, and county was named,
For General Robert F. Hoke, a man far-famed.
We are in easy reach of the mountains or sea,
A desirable place to live, you'll agree.
So here's to the Baby County of Hoke,
Blessing always, on thee, we invoke.

One

BEGINNING

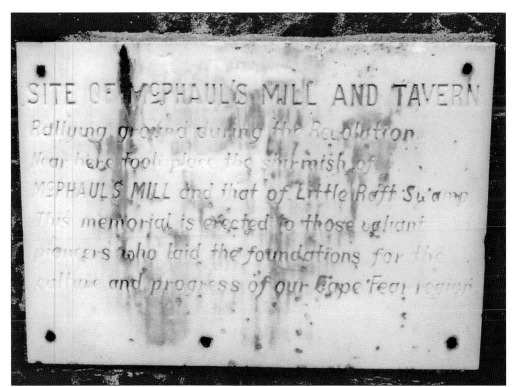

McPhaul's Mill and Tavern, c. 1770. A marker was erected at the site of this historically famous mill and tavern on April 30, 1933. The marker bears this inscription: "Site of McPhauls Mill and Tavern, rallying ground during the Revolution. Near here took place the Skirmish of McPhaul's Mill and Little Raft Swamp. This memorial is erected to those valiant pioneers who laid the foundation for the culture and progress of our Cape Fear section." (Courtesy of Raeford-Hoke Museum.)

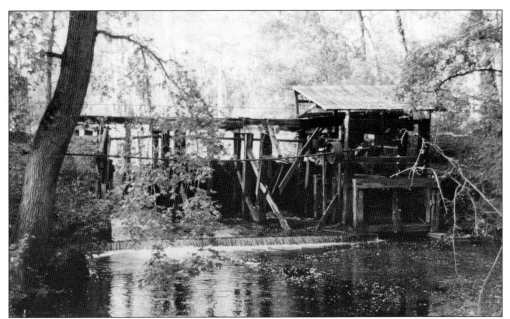

PUPPY CREEK GRISTMILL. A well-known gristmill and sawmill were built around 1818–1822 on the MacGregor-Lamont-Johnson Plantation. The plantation, house, and gristmill were burned during the Civil War, but the plantation house was saved. F. P. Johnson rebuilt the gristmill around 1911 as a commercial mill for corn meal. It was a water-powered stone-grinding mill. (Courtesy of Luke McNeill.)

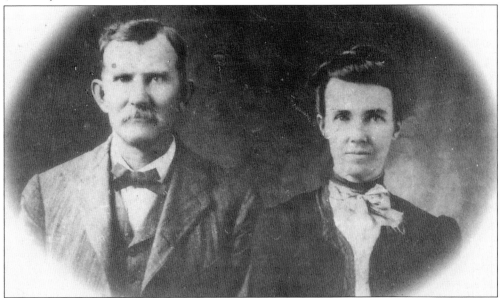

JOHN A. MCPHAUL, 1861–1931. John A. McPhaul and Jane Ellen Conoly McPhaul were married in 1888. These families were among the earliest 18th-century Highland Scottish settlers to the area. McPhaul was a successful farmer and businessman and served on the original Hoke County Commission. His immigrant ancestor and namesake, "Old John McPhaul," arrived in the Raft Swamp area before 1761 and operated the historic McPhaul Mill and Tavern near Antioch. (Courtesy of Jim Sinclair.)

MONROE HOME, 1755–1918. The old Monroe home was built around the year 1755 for immigrant Daniel (Donald Gaelie) Monroe. In 1918, the federal government destroyed the home and cemetery to make way for the army cantonment, which is now Fort Bragg and Pope Air Force Base. In 1993, a monument was installed in memory of the Monroe family members and their old home. (Courtesy of Virginia Monroe McCall.)

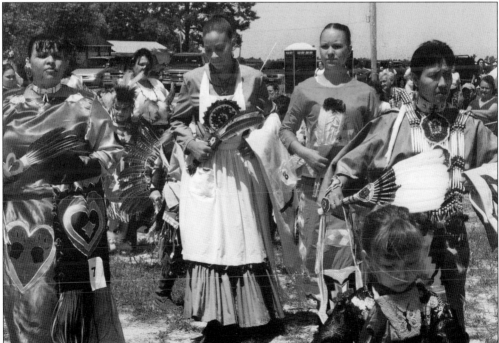

LUMBEE INDIANS, A PEOPLE OF TRADITIONS. The Lumbee Indians are present-day descendants of the Cheraw tribe and have lived in Robeson, Hoke, and surrounding counties since the early part of the 18th century. When Scottish immigrants began to settle the upper reaches of North Carolina's Cape Fear Valley in the early 1730s, they were amazed to find a tribe of English-speaking Native Americans already living near the Lumber River. (Courtesy of Gwen Locklear.)

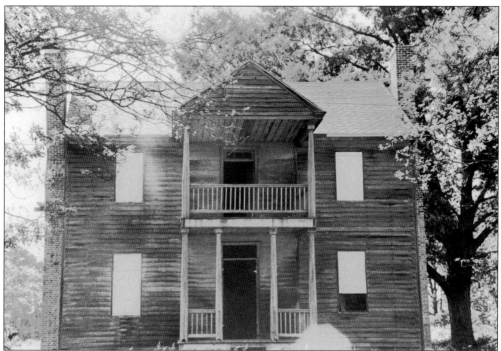

MILL PRONG HOUSE, C. 1802. The Mill Prong house, built in early 1802, has existed in two counties, first Robeson, now Hoke. On this little road, which in former days was an artery across the state, a tall frame house stands in lonely dignity among the architectures belonging to the past century. It is known locally as "Mill Prong," being situated on a slight rise overlooking Little Raft Swamp. Historians believe John Gilchrist built the house in 1802. Gen. William Tecumseh Sherman camped nearby on his infamous tour of the Carolinas and hundreds passed through when the stagecoach stopped here to change horses. Nobody knows who lived here last, but tenant farmers kept the place until the 1930s or 1940s. The house has been restored and is now open on the first Sunday of each month as a museum.

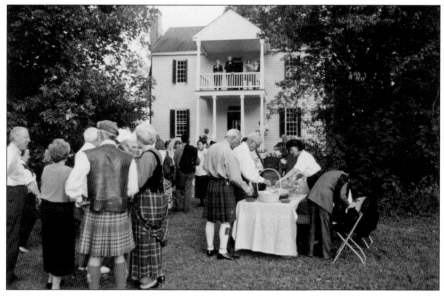

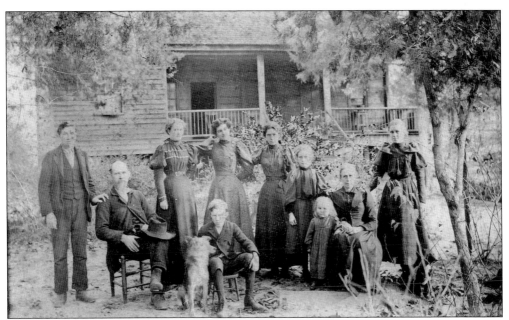

SINCLAIR FAMILY AT BUFFALO CREEK, 1897. The Sinclair family is pictured at their home on Buffalo Creek, now Hoke County. Pictured are, from left to right, (first row) John T. Sinclair Sr., Shep the dog, Neill Blue Sinclair Sr., Ina Sinclair (Wright), and Eliza N. Blue Sinclair; (second row) Dickson Sinclair, Mary Eliza Sinclair, Margaret Currie, Fannie C. Sinclair (Walters), Beatrice S. Sinclair, and Kate Sinclair. John T. Sinclair Sr. was a Civil War veteran. They all moved to Raeford around 1901. (Courtesy of Jim Sinclair.)

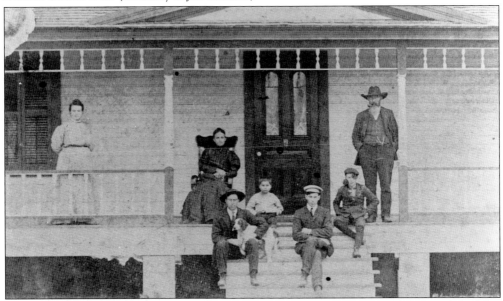

NIVEN FAMILY, RAEFORD. John A. Niven married Mittie Williams Niven, and the couple had five children. John owned a general store, and later his daughter Sarah Elizabeth, "Miss Lizzie, owned the Ladies Shop in Raeford. Photographed are, from left to right, (seated on steps) Percy Duncan Niven, Lola A. Niven, Thomas Reece Niven, and Julius Franklin Niven; (on the porch) Sarah Elizabeth Niven, Mittie Williams Niven, and John A. Niven. (Courtesy of William T. Niven.)

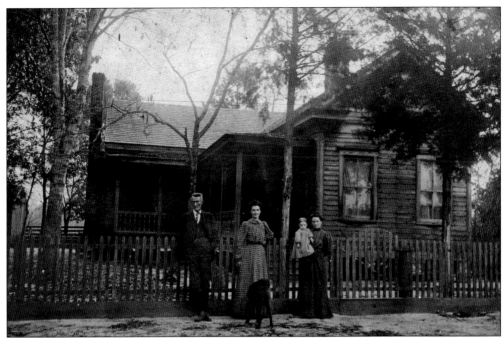

DR. W. G. RAY, MCLAUCHLIN TOWNSHIP. Dr. W. G. Ray, grandson of John Ray and father of Willa Ray Parker, attended Edenborough Medical College and eventually held physician's certificate No. 16 from the State of North Carolina. He was born without a right arm, which kept him from following in the family's farming tradition. Here, in about 1910, Dr. Ray stands with one daughter, Sally Ray; a daughter-in-law, Anna W. Ray; and her child. (Courtesy of Richard Neeley.)

WILL AND BESSIE MONROE, 1895. William Malcolm Monroe Jr. was born March 9, 1895, the son of William Monroe Sr. and Cynisca English Davis. He married Bessie Bell Andrews, and they had five children. Will and Bessie lived in the house built by his grandfather in the Wayside Community of Hoke County. Will Monroe served as a county commissioner and elder of Galatia Presbyterian Church. (Courtesy of Raeford-Hoke Museum.)

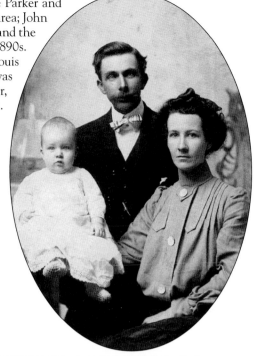

PORTRAIT OF LOUIS AND WILLA PARKER. The Parker and Ray families were settlers of the Hoke County area; John Ray settled along Rockfish Creek in the 1740s and the Parkers moved from South Carolina in the 1890s. Ray's great-granddaughter Willa Ray married Louis Parker in 1903. In 1905, this formal portrait was taken with their first child, Clyde Ray Parker, who died within a month of this photograph. (Courtesy of Richard Neeley.)

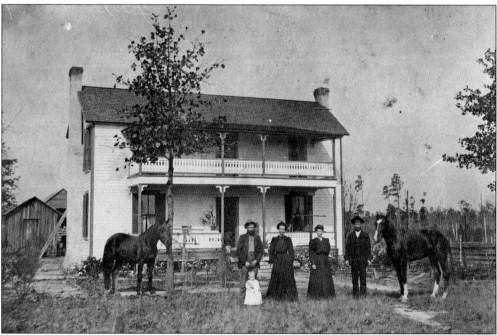

PARKER HOUSE, 1905. In this 1905 photograph, a log cabin from the early 1800s is behind the Parker house. Louis Parker lived inside the cabin while he cleared the land and built the new house. Pictured are, from left to right, Louis Parker and child Clyde Ray Parker, Willa Ray Parker, Louis's sister Mary Parker, and hired hand John David. Louis and Mary Parker were involved in the founding of Parker's Church. (Courtesy of Richard Neeley.)

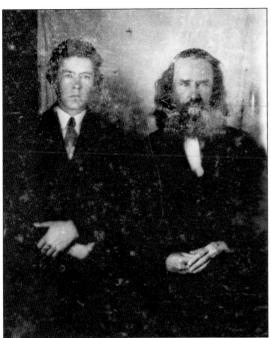

DR. HECTOR MCLEAN (1818–1877), PHYSICIAN. Pictured here are Dr. Hector McLean and his son A. Murphy McLean. Dr. McLean was born in 1818 to Scottish parents in Robeson County, now Hoke County. His father, John McLean, was also a physician. As early as 1857, he began a medical practice at his home, "Edenborough," near the present site of Raeford. Here Dr. McLean established his extensive practice, which extended from Randolph County into South Carolina. He founded the Edenborough Medical College and successfully maintained large farming interests within his estate.

EDENBOROUGH MEDICAL COLLEGE, (1867–C. 1877). The first medical school in North Carolina was officially chartered by Dr. Hector McLean in 1867 at his estate, "Edenborough," just south of the present-day Raeford. The innovative physician constructed a building adjacent to his home in which he instructed small classes in medical procedures, surgery, and pharmaceutical preparation. Many of these doctors served the local community, and others migrated to the southwest. (Courtesy of Dr. William McLendon-Pamphlet/Chapel Hill.)

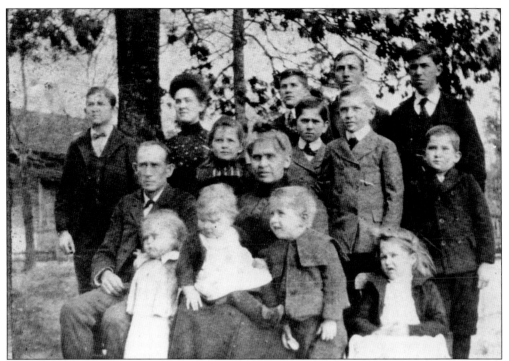

A Country Doctor, 1880. This pictures shows Dr. Albert Pickett Dickson, his wife, Frances Wyatt DeVane Dickson, and their 13 children. In 1880, Dickson came to the Raeford area to practice medicine. Although he was involved in all phases of community development, he was the consummate country doctor, traveling by horse and buggy to deliver babies, treat all kinds of illnesses, bind wounds, pull teeth, and set bones. Dickson is buried near his old home. Little else besides his gravestone is left to commemorate the life of this brilliant, interesting man. (Courtesy of Dr. William McLendon-Pamphlet/Chapel Hill.)

Raeford Institute, 1895. Dr. Albert Pickett Dickson and his wife asked John W. McLauchlin to help found a school to educate their 13 children. The McRae family gave 4 acres for the location of a school and many other families gave $20 each. A two-story building was erected, and Raeford Institute began operations in September 1895 with two teachers. (Courtesy of North Carolina Collection, University of North Carolina Library at Chapel Hill.)

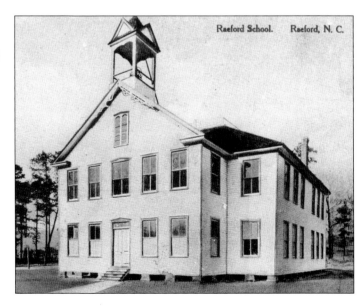

Raeford School. Raeford, N. C.

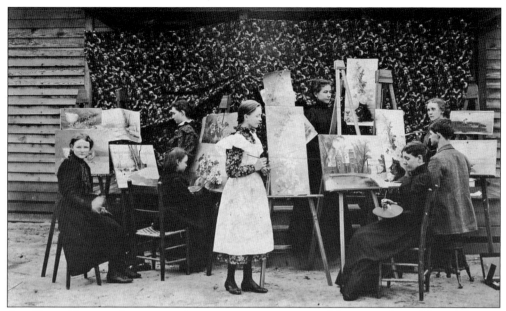

ART CLASS, RAEFORD INSTITUTE. Art was an important part of the curriculum of the students at Raeford Institute. Some of the students listed in the art exhibit catalog of 1905 are Bessie Blue, Bonnie Blue, Willie Currie, Louis Rhodes, Janie Black, Katie McBryde, Beulah Cameron, Agnes Upchurch, W. T. Covington, and N. T. McDonald. The students in this picture are unidentified. (Courtesy of Raeford-Hoke Museum.)

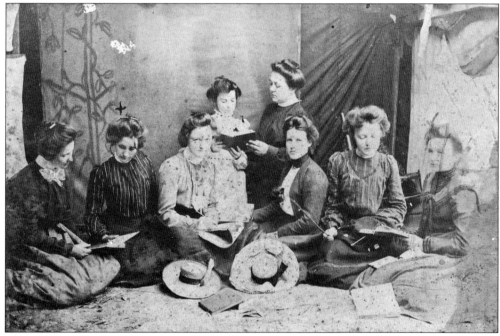

MUSIC CLASS, RAEFORD INSTITUTE. Pictured here are music students at Raeford Institute with music teacher Willie B. McQueen in the center. Beulah Campbell McIntyre ran a boardinghouse, and her two daughters are in this group. To the far left is Sudie Maxwell Fletcher. (Courtesy of Raeford-Hoke Museum.)

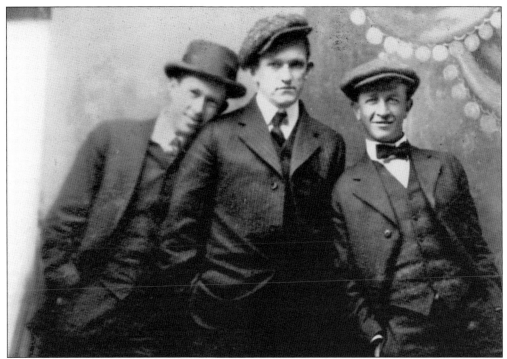

EARLY CITIZENS OF HOKE COUNTY. Three well-known early citizens of Hoke County are shown in this picture. The friends are, from left to right, Neill B. Sinclair, William L. Poole, and Bill Heins. All were students of the Raeford Institute.

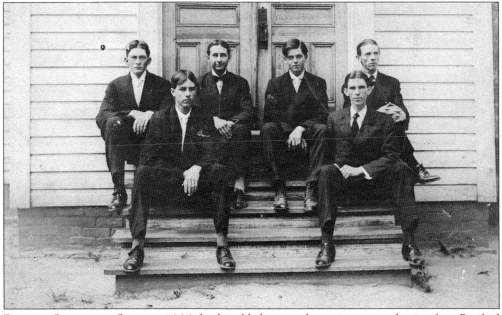

RAEFORD INSTITUTE, CLASS OF 1900. In this old photograph are six men graduating from Raeford Institute in 1900. The college preparatory facility was built in 1895. Not all the men have been identified, but the gentleman in the back row, far left is Lacy Clark, Raeford postmaster in the 1940s and 1950s. (Courtesy of Raeford-Hoke Museum.)

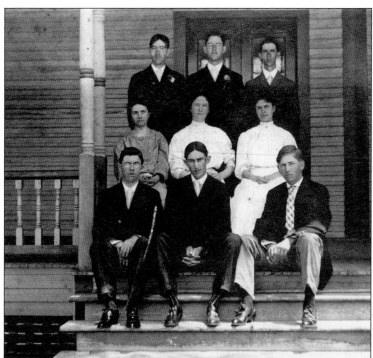

SENIOR CLASS, RAEFORD INSTITUTE, 1907. The Raeford Institute graduating class of 1907 is pictured at left. From left to right are (first row) Daniel Archie McNeill, Will McLean, and Paul Dickson; (second row) Lettie Rhodes, Beatrice Sinclair, and Annie McKeithan; (third row) John McGoogan, Ben McGoogan, and Hector McDiarmid. (Courtesy of Jim Sinclair.)

RAEFORD INSTITUTE STUDENTS. Many families moved to Raeford to educate their children. The Raeford Institute helped boost the population around the area that is now Hoke County. Students photographed in this picture are, from left to right, Lydia Ann McKeithan, Mary Eliza ("Mayme") Sinclair, Margaret Lee Currie, Beatrice Sinclair, and Malcolm Luther ("Make") McKeithan.

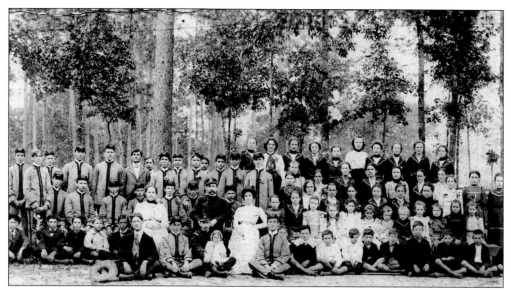

RAEFORD INSTITUTE, 1904. School enrollment increased as families moved to the area. The total student body was photographed in this 1895 picture. The Raeford Educational Association was formed to support the school. The purpose of the association was not to make money, but to provide for the educational interests of the community. By January 1904, the student body had grown to 325. (Courtesy of James and Dodie Currie.)

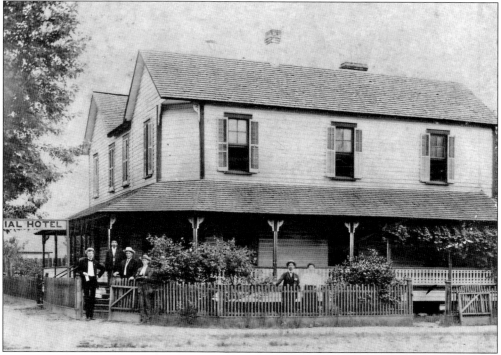

GILLIS HOUSE, EARLY HOTEL. The Gillis House was one of the first hotels in Raeford. It was located at the corner of Main Street where the courthouse annex is today. Catherine Blue Gillis built and operated the hotel. Her parents were Neill McK. and Eliza Smith Blue, whose large and prominent family lived at Blue's Mountain, now on the Fort Bragg Reservation.

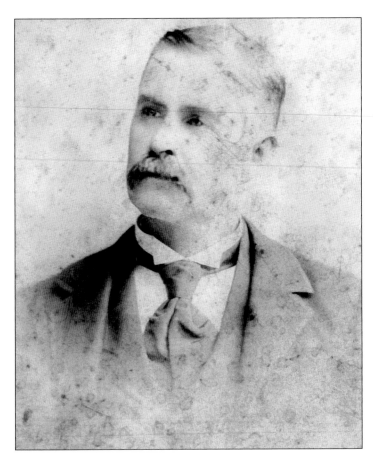

JOHN BLUE (1845–1922), BUSINESS LEADER. In 1874, John Blue married Fannie A. Owen of Cumberland County, and they had eight children. Blue accumulated large timber-farming interests. In 1892, he chartered the Aberdeen and Rockfish Railroad, which continues to operate successfully today. He served as state senator for Cumberland and Harnett Counties in 1881. A Presbyterian, he had leadership roles in both Sandy Grove and Bethesda churches. (Courtesy of Jim Sinclair.)

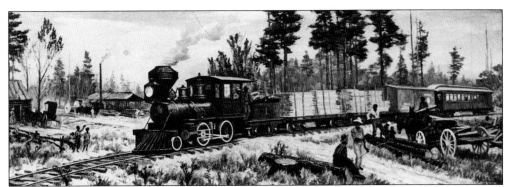

ABERDEEN AND ROCKFISH RAILROAD. In 1885, sawmill men came to the sandhills country. As the demand for pine increased, so did the need to transport it. John Blue organized the Aberdeen and Rockfish Railroad in 1892. This is a painting of the No. 1 train traveling through a longleaf pine forest representing what was called "sandhills" railroading around the turn of the century. (Courtesy of Aberdeen and Rockfish Railroad.)

Neill S. Blue, 1848–1929, Businessman-Benefactor. Neill S. Blue married Mary Eliza Blue, and they had seven children. He was born to Neill McK. and Eliza S. Blue and was raised at Blues Mountain/ Battlefield Farm on Fort Bragg Reservation. Blue engaged in extensive and successful farming, timber, turpentine, railroad, and banking businesses. Once considered the largest landowner in North Carolina, he negotiated approximately 11,000 acres to the federal government in the formation of Fort Bragg. He endowed and supported many charitable and civic causes during the building stages of Hoke County. (Courtesy of Jim Sinclair.)

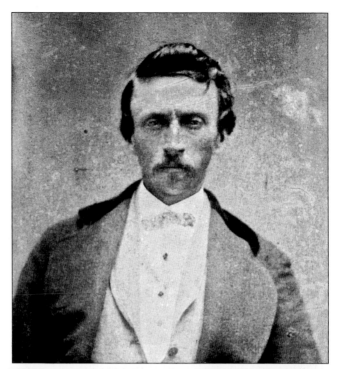

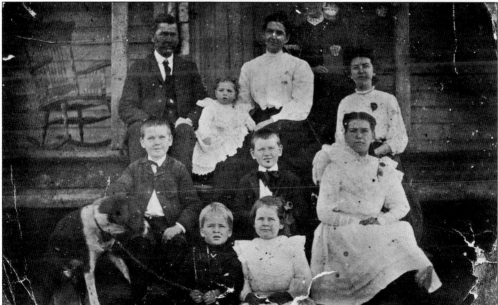

Archibald McFadyen Family. Descendents of Archibald McFadyen, who came to the United States in 1785, are seen in this picture. They settled in the area that is now Fort Bragg Reservation. From left to right are (first row) the family dog, George Arthur McFadyen, and Mary Eliza McFadyen; (second row) Archibald Franklin McFadyen, Dougald Alexander McFadyen, and Annie McFadyen (Warren); (third row) Archibald Buie McFadyen, Jennie Eloise McFadyen, Jennie McDiarmid McFadyen, and Kate McFadyen (Cobb). The woman at the top is not in immediate family. (Courtesy of William Chandler Roberts.)

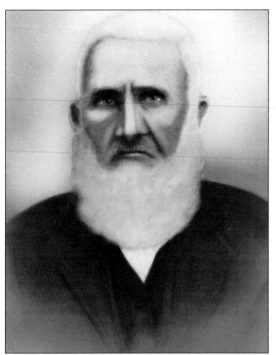

A Settler Before Hoke County Was Formed. Levi Ellis was born in 1822 in Richmond County, and later moved to Hoke County. Levi Ellis and Easter Ellen Pate Ellis lived in Hoke County until he died in 1910. Easter then moved into the home of her son and wife, William Henry and Katherine Elizabeth Currie Ellis. Easter died in 1914. William and Katherine Ellis each died in 1949, just six months apart. They reared nine children on a farm in Quewhiffle Township in Hoke County. They were William Clifton, Ralph, Margaret Belle, John Levi (Jack), Henry Wallace, Eula Mae, Katie Clyde, Eunice Lillian and Minnie Gertrude. From this union there were many spouses, grandchildren, great-grandchildren and great-great-grandchildren. They all remember the heritage of the family farm in Hoke County that was the beginning for their lives. (Courtesy of Connie F. Ellis.)

Annie Lindsay McFadyen Family. Annie Lindsay, in the middle holding the Bible, is pictured with her children. She was born on November 11, 1822, and died September 14, 1892. She was married to Dougald McFadyen. From left to right are (first row) Catherine Ann McFadyen Graham, Mary Isabelle McFadyen, Annie Black Lindsay, Elizabeth Jane McFadyen Clark, Effie Turner McFadyen McDiarmid, and Dougald Alexander Stephens McFadyen; (second row) John Fleetwood McFadyen, Daniel Graham McFadyen, Archibald Buie McFadyen, Neill Lindsay McFadyen, James Vance McFadyen, and Duncan Black McFadyen. (Courtesy of Chandler Roberts.)

NEILL BONNIE BLUE, 1890. Neill Bonnie Blue was born in 1890 in the part of Hoke County that is now the Fort Bragg Reservation. He was the son of Neill Smith Blue and Mollie Blue, and his father was one of the founders of the Aberdeen and Rockfish Railroad. Blue attended Raeford Institute and was a talented amateur artist, both in oils and watercolor. He married Mayme Blue Blue, and they had three children. (Courtesy of Mike Hoffman.)

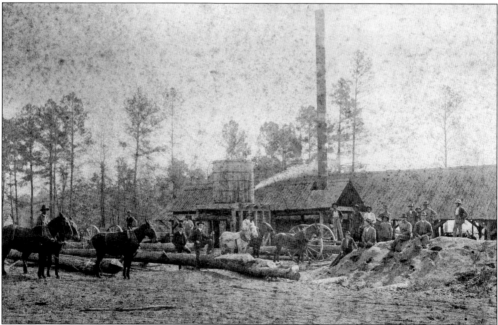

A NEW ERA, SAWMILLS. William J. Upchurch and Thomas B. Upchurch Sr. operated one of the first sawmills in the county. With the help of the tram road built by Aberdeen and Rockfish Railroad, they were able to transport lumber. By the late 1920s and early 1930s, there were a number of sawmills in Hoke County.

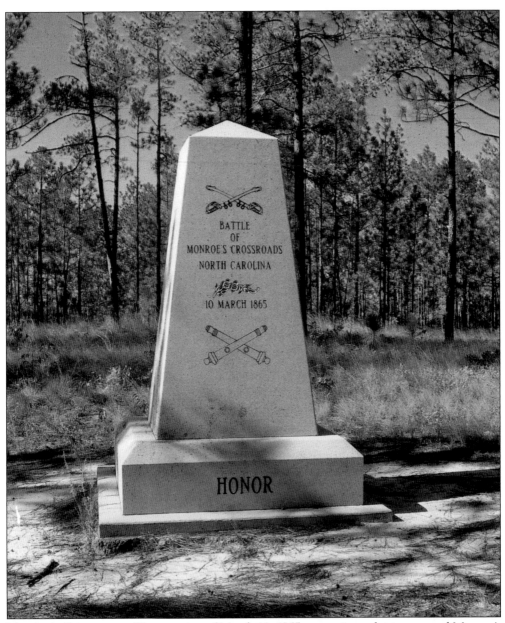

MONROE'S CROSSROADS. The morning of March 10, 1865, was quiet and misty around Monroe's Crossroads, with a low-hanging fog covering the swampy ground. Four brigades of Union troops under the command of Maj. Gen. Judson "Hugh" Kilpatrick were camped on the low ridge beyond the swamp, which is now part of Fort Bragg. In the early morning hours, Kilpatrick was dressed in his underwear, checking his horses. With a piercing rebel yell, Confederate cavalry troops charged. The Confederate forces under generals "Fighting Joe" Wheeler and M. C. Butler caught the Yanks by surprise. Many Federal soldiers surrendered immediately. Others seized their weapons and fled into the swamps. Within five minutes, the entire camp had been overrun, and some fierce hand-to-hand fighting occurred. This was the only Civil War battle fought in the area. A monument marks the battleground and is preserved by the U.S. Army. (Courtesy of Fort Bragg Cultural Resources Management Program.)

WILLIAM MALCOLM MONROE SR. FAMILY. William was a descendent of Neill Monroe who lived near the Piney Bottom Creek and in the present Fort Bragg Reservation. William and his wife, Cynescia English Davis, had six children and lived in McLauchlin Township of Hoke County. Five of the children are pictured in this photograph; from left to right are George Monroe, Flora Monroe Wood, Ruth Monroe Willis, William Malcolm Monroe Jr., and Floyd Monroe. All were members of Galatia Presbyterian Church and are buried in the church cemetery. (Courtesy of Margaret Willis English.)

CHILDREN OF NEILL PATRICK CONOLY. Neill Patrick Conoly was a descendant of Daniel Conoly, who came to the United States in 1793. The Conoly family settled around the Antioch area that is now Hoke County. The Conoly children are pictured, from left to right, Lela Conoly McQuage, Willa Conoly Jones, Neill Archibald Conoly, Cora Jane Conoly McMillan, Flora Margaret Conoly Baker, and Charles Clifton Conoly. (Courtesy of Don Conoly.)

SCULL ANNIVERSARY. J. W. and Annie Catherine Hall Scull celebrated their golden anniversary with family and friends. Annie's parents were William S. and Margaret Ann McGougan Hall. The Sculls, who had 11 children, 15 grandchildren, and one great-grandchild, were farmers who lived in the Wayside community of Hoke County. (Courtesy of Gary Josh Scull.)

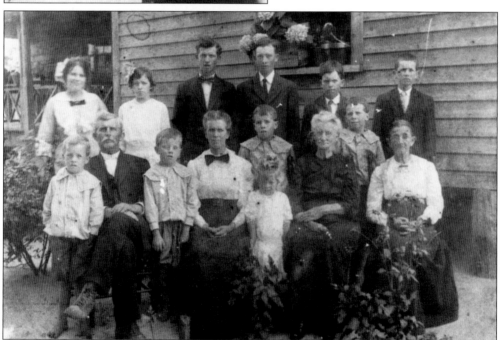

GARY AND MOLLIE PARKER. Gary Parker married Mollie Gibson in 1890. He was born July 1869 in the community of Blue Springs. The Parkers had 11 children. They are pictured here, in no particular order: Wright, Harris, Alma, William, Fletcher, Gus, Kirk, John, Mary, Ina, and Henry. Also pictured is Gary's sister. (Courtesy of Gary Josh Scull.)

FIVE GENERATIONS OF THE CLARK FAMILY. The Clark family lived in the Rockfish area of Hoke County. John Nelson Clark born in 1890 is pictured at age 93 and Alex Clark, his son, at age 63. They were both tenant farmers. Family members pictured here are, from left to right, (first row) John Nelson Clark and Elnora Clark Graham holding Jamelle Graham, her grandson; (second row) James Graham and Alex Clark. (Courtesy of Ellen McNeill.)

DUNCAN DAVID BLACK FAMILY. Members of the Black family appearing in this photograph are, from left to right, (first row) Bobby Brown, grandson of Neill Black; (second row) Betty Black Parker's children Elizabeth B. Parker, Duncan David (called D. B. Parker), and Davis K. Parker Jr.; (third row) Duncan David, Katie Black, Neill D. Black, Elizabeth J. Black, Margaret Black, and Allie Black. (Courtesy of Elizabeth McPherson.)

NEILL LAUCHLIN AND MARY VIRGINIA McFADYEN, 1911. Neill Lauchlin McFadyen was the son of William McFadyen, of McLauchlin Township. He married Mary Virginia McLean, of Maxton, and they had four children—Neill Jr., Virginia, Bill, and John. Lauchlin was a farmer, served on the board of education, and represented Hoke County in the House of Representatives. They were the second owners of the home that is now the Raeford-Hoke Museum. (Courtesy of Raeford-Hoke Museum.)

LEACH FAMILY, 1801. Dougald Leach married Mary McCallum in Scotland before they came to America in 1801. Kay Leach, a descendent of Dougald Leach, married Laura McBryde; they are pictured with their children. In the center are Kay and Laura Leach; standing from left to right are John, Willard, Mary Jane, and Gilmar. Kay Leach was the grandfather of Alfred K. Leach Sr. (Courtesy of Sarah Leach.)

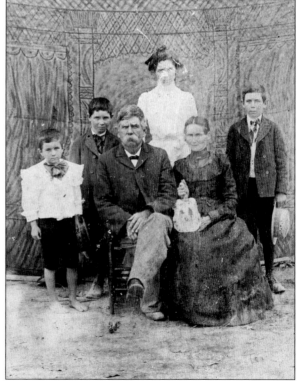

Two

PROGRESS

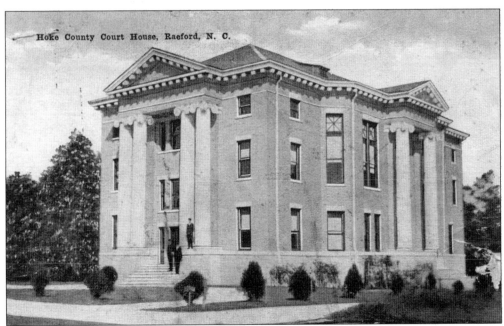

HOKE COUNTY COURTHOUSE DESCRIPTION. The Hoke County Courthouse is a modest neoclassical revival structure. The three-story tan brick building rests on a high ashlar base and a tetra-style pedimented ionic portico, which frames the main entrance, fronts its main facade. A small portico boxes the secondary entrance on the south facade. A cornice with modillion and dentil courses defines the base of the hipped roof. (Courtesy of Raeford-Hoke Museum.)

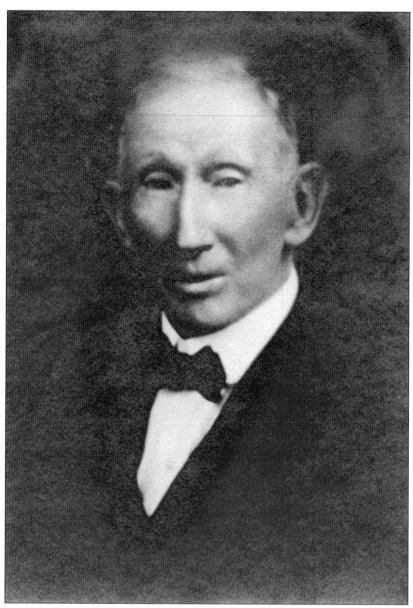

JOHN WILLIAMSON MCLAUCHLIN, STATE SENATOR. John W. McLauchlin was born on April 16, 1846. He was a major in the Civil War and an alumnus of Davidson College. McLauchlin never sought political preferment, but his fellow citizens drafted him on three occasions to serve as state senator from Cumberland County. He was largely responsible for the lawful establishment of Hoke County in 1911. He was a founder of one of the oldest companies in Raeford, the McLauchlin Company, and helped organize the Bank of Raeford, where he served as the second president. In all matters of civic importance or personal decision, his opinion was sought and prized. His benevolence is attested by the many gifts he contributed to worthy causes, including land donations to churches, schools, and community organizations. McLauchlin's character embraced the Christian virtues of humility, unselfishness, and devotion. His manner was always quiet and gracious; his opposition to any measure or man was firm and well-founded. He is honored as the "Father of Hoke County." (Courtesy of Raeford-Hoke Museum.)

JOHN W. MCLAUCHLIN SCULPTURE. Hoke County honored Sen. John Williamson McLauchlin on December 28, 1911, when W. T. Covington, a sculptor and close friend of McLauchlin, officially presented to the county a bust of McLauchlin. Covington made the sculpture to be placed in a niche in the wall of the lobby of the courthouse. The engraving under the bust reads, "Father of Hoke County." (Courtesy of Raeford-Hoke Museum.)

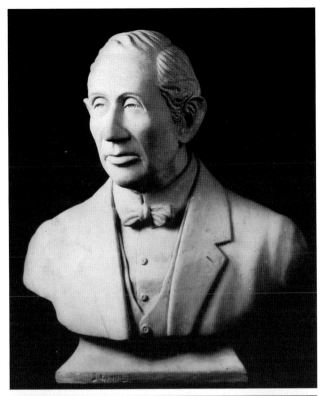

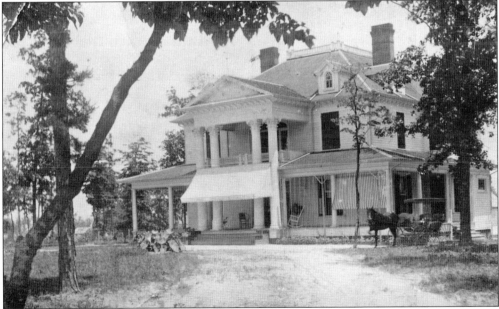

JOHN W. MCLAUCHLIN HOME. John W. McLauchlin and his wife, Christina, built a gracious home on Highland Street in Raeford that was a wedding gift to each other. Lumber for the home was from the longleaf pines on McLauchlin's land. It is of neoclassical revival design and contains 6,000 square feet. The house is now the home of the Raeford-Hoke Museum. (Courtesy of Raeford-Hoke Museum.)

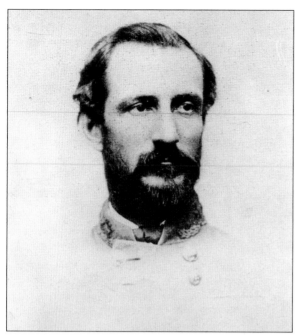

HOKE GENERAL OF CIVIL WAR. Hoke County, formed in 1911, took its name from the former Confederate general Robert F. Hoke, who was much admired for his wartime achievements. Hoke was the youngest major general to ever serve in the Confederate army. After the war ended, he concentrated on building a new South. He was a successful and spirited businessman. (Courtesy of Raeford-Hoke Museum.)

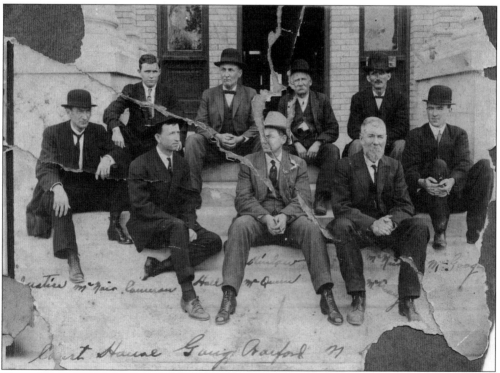

HOKE COUNTY OFFICIALS, 1912. Before the courthouse was completed, office space had to be rented at other locations for the county officials, including those in this photograph. Pictured on the courthouse steps are, from left to right, (first row) H. A. Cameron, W. B. McQueen, and W. J. McCraney; (second row) B. J. Justice, Arch McNair, Edgar Hall, D. J. Kinlaw, John McNair, and J. Hector Smith. (Courtesy of Raeford-Hoke Museum.)

FIRST SHERIFF OF HOKE COUNTY.
Edgar Hall, born in 1868, was
the first sheriff of Hoke County
and a county official for 30 years.
He founded Dundarrach Trading
Company and for a few years was
a proprietor of a lumberyard and
mill. An early supporter of the new
county movement, he was named
sheriff by Governor Kitchen in 1911.
(Courtesy of Raeford-Hoke Museum.)

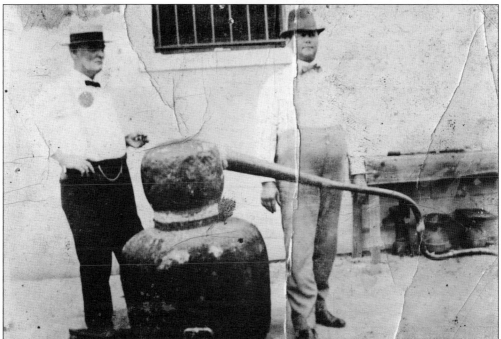

SHERIFF HALL AND JAILER COCKMAN. The area that is now Hoke was a wilderness of pine forests.
There were no roads, only tracks of two-rut trails that connected the houses and farms. One of the
first duties of the new sheriff was to find and destroy local stills. Pictured are Sheriff Edgar Hall (left)
and jailer L. B. Cockman destroying one of the illegal stills. (Courtesy of Raeford-Hoke Museum.)

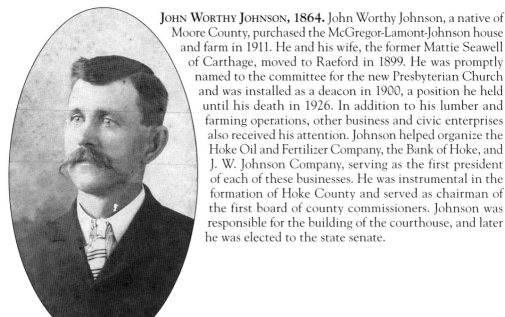

JOHN WORTHY JOHNSON, 1864. John Worthy Johnson, a native of Moore County, purchased the McGregor-Lamont-Johnson house and farm in 1911. He and his wife, the former Mattie Seawell of Carthage, moved to Raeford in 1899. He was promptly named to the committee for the new Presbyterian Church and was installed as a deacon in 1900, a position he held until his death in 1926. In addition to his lumber and farming operations, other business and civic enterprises also received his attention. Johnson helped organize the Hoke Oil and Fertilizer Company, the Bank of Hoke, and J. W. Johnson Company, serving as the first president of each of these businesses. He was instrumental in the formation of Hoke County and served as chairman of the first board of county commissioners. Johnson was responsible for the building of the courthouse, and later he was elected to the state senate.

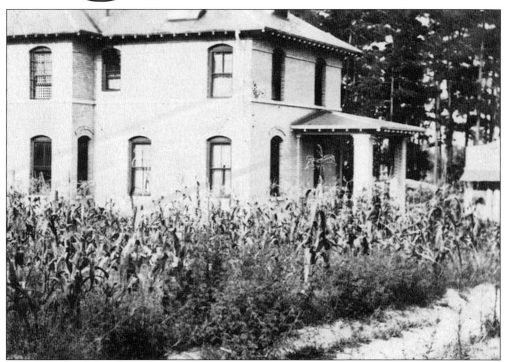

HOKE COUNTY JAIL, 1912. One of the first decisions for the newly elected county commissioners was to build a courthouse and jail. They were constructed at a cost of $38,000, and the ironwork for the jailhouse cost the taxpayers another $4,000. In 1968, a new jail was built for $160,000, and in 2009, another detention facility was completed at a cost of $8.5 million. (Courtesy of Raeford-Hoke Museum.)

U.S. RANGER, SGT. JOHN SIDNEY MOTT.
Sgt. John Sidney Mott, who served in
France during World War I, was born
in Ellaville, Georgia. A ranger at Fort
Bragg, he was shot while arresting four
Asheboro men for illegally poaching on
the reservation. Mott was married to Mary
Parker and was the father of Robert and
Myra. They attended Parkers Methodist
Church, founded by Mary's family. Mott's
Lake on Fort Bragg honors him with a
marker. (Courtesy of Ellen K. Parker.)

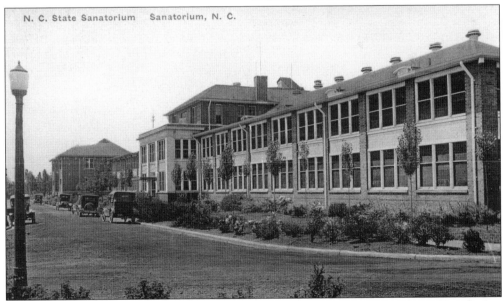

NORTH CAROLINA SANATORIUM, 1908. The North Carolina Sanatorium opened in 1908 as the first
state institution in North Carolina for treating tuberculosis. Dr. James. E. Brooks was superintendent
until 1914 when Dr. Paul McCain was named superintendent. The sanatorium's name changed to
McCain Hospital in 1973, after McCain was killed in an automobile accident. In October 1983,
the hospital was deeded to the state and the name changed to McCain Correctional Hospital.
(North Carolina Collection of the University of North Carolina Library at Chapel Hill.)

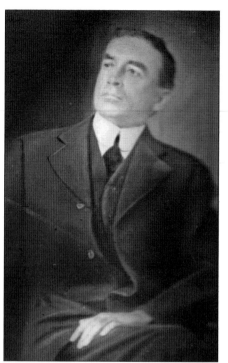

HOKE COUNTY'S FIRST ATTORNEY. James Wharey Currie came to Raeford to practice law and to aid in the formation of Hoke County. He was elected to serve as county attorney and held this position until his death in 1935. Currie later represented the interests of the citizens who were forced to sell their property to the federal government when Fort Bragg was created in 1918. (Courtesy of Raeford-Hoke Museum.)

HUGH MCCALLUM CURRIE FAMILY. This photograph of the Hugh McCallum Currie family was taken on August 25, 1904. Currie was born in Robeson County (now Hoke County) in 1851 and was wed to Mary Bennett Holt. Pictured are, from left to right, (first row) Benjamin, Laura, Mary, Jennie, and Duncan; (second row) Edwin, Hugh McCallum, Hugh Alexander, Mary Bennett Holt Currie, Eunice, and Will; (third row) Scott, Sterling, and John. Currie was the first clerk of the session of Raeford Presbyterian Church and was a charter member. (Courtesy of Grace Carter [nee Dodie] Currie.)

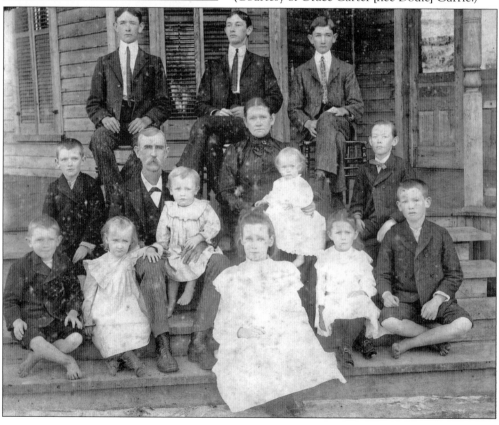

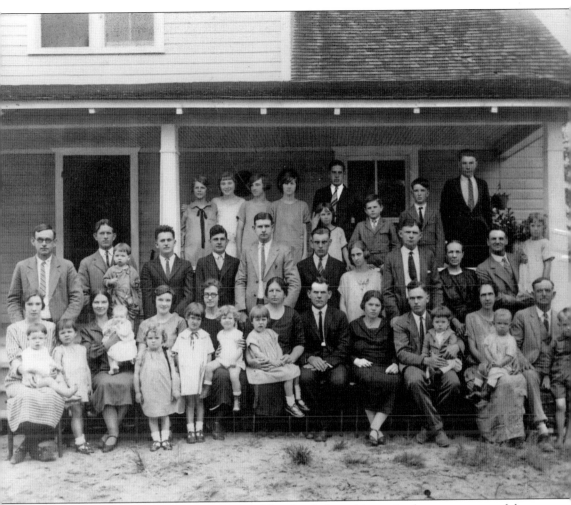

STROTHER FAMILY, QUEWHIFFLE TOWNSHIP. This family has a history in the western part of the county and initially were farmers in the area. Photographed from left to right are (first row) Mary Ina Thompson Crouch, Chesley Thomas Crouch Jr., Bucilla Crouch, Inez Pickler Crouch, Lana Bell Crouch, Susie Strother Sides, Magdalene Sides, Ida Strother Porterfield, Marian Porterfield, Rachel Porterfield, Della Strother Crouch, Mildred Crouch, James Calvin Crouch, Nora Belle Sides Strother, Robert Dewey Strother Sr., Robert Dewey Strother Jr., Minnie Lou Long Strother, Elsie Strother, John Wesley Strother, and Robert Luther Strother; (second row) Chesley Thomas Crouch Sr., Arley Crouch, Calvin Crouch, Mart Sides, Fletcher Porterfield, William Crouch, George Vanhoy, Lilly Strother Vanhoy, Jonah Thompson, Frances Long, P. Thompson, Charles Strother, and Ora Strother; (third row) Bertha Crouch, Minnie Thompson, Alice Strother Almond, Gladys Crouch, Thelma Strother Melvin, J. C. Crouch, and A. L Strother, (fourth row) Joe Smith and Chips Thompson. (Courtesy of Judy Strother.)

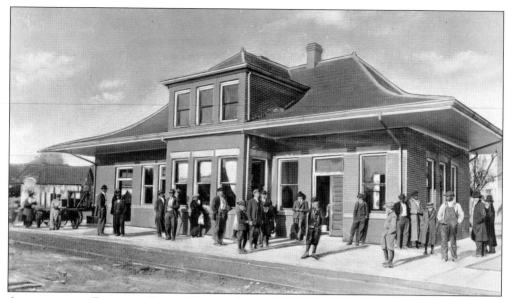

ABERDEEN AND ROCKFISH DEPOT. During the winter of 1895, John Blue, Hector Smith, Dan McLauchlin, and Max Folley came to Raeford on a train from Aberdeen and collectively decided that the area needed a depot, which eventually came to fruition and is pictured here. The depot is used today as the office of the chamber of commerce. (Courtesy of North Carolina Collection, University of North Carolina Library at Chapel Hill.)

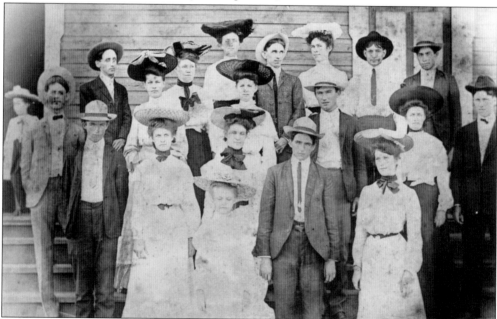

RAEFORD DEPOT, 1904. A group of friends of John McK. Sinclair said goodbye as he left for his home in Georgia. From left to right are (first row) Mayme McKeithan, Dan McKeithan, and Beatrice Sinclair; (second row) Martin McKeithan, Annie McKeithan, Kate Sinclair, Dan Campbell, Beulah Morris, unidentified, Pearl McKeithan, two unidentified, Mary Eliza Sinclair, Mayme McKeithan, three unidentified, Christian McKeithan, unidentified, Fanny Sinclair, unidentified, and Malcolm ("Make") McKeithan. (Courtesy of John Sinclair.)

FORT BRAGG, FOUNDED 1918. In 1917, U.S. Army officers visited several states to survey lands suitable for the development of temporary field artillery training camps. Maj. Gen. William J. Snow, chief of artillery, selected an area near Fayetteville, North Carolina, for one such wartime facility—the genesis of modern-day Fort Bragg. This field artillery cantonment and training center eventually encompassed some 92,000 acres of Hoke County land. (Courtesy of U.S. Army Fort Bragg Cultural Resources Management Program.)

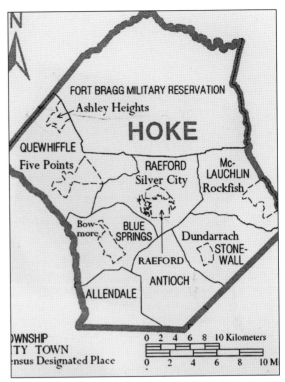

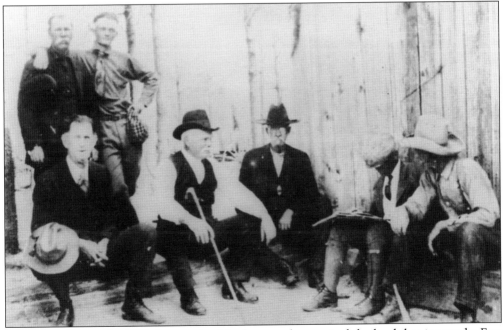

APPRAISAL GROUP. In 1919, the men in this photograph appraised the land that is now the Fort Bragg Reservation. From left to right are (seated) B. R. Gatlin, W. P. Lester, Hector Smith, an army engineer, and the property owner; (standing) A. B. McFadyen and an army driver called "Red." The appraisal committee was composed of Gatlin, Lester, and McFadyen. (Courtesy of Chandler Roberts.)

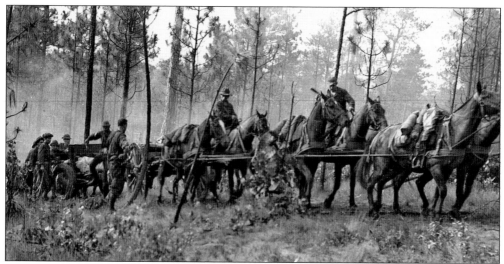

HORSES AND SOLDIERS. Although mechanized heavy artillery units were stationed at Fort Bragg in the 1930s and 1940s, many units continued to rely on horses or mules for transport. Horse teams pulling guns, caissons, and supply wagons or heavily laden pack mules burdened with howitzer barrels, gun carriage components, or ammunition were once a common sight in the longleaf pine forests of northern Hoke County. (Courtesy of U.S. Army Fort Bragg Cultural Resources Management Program.)

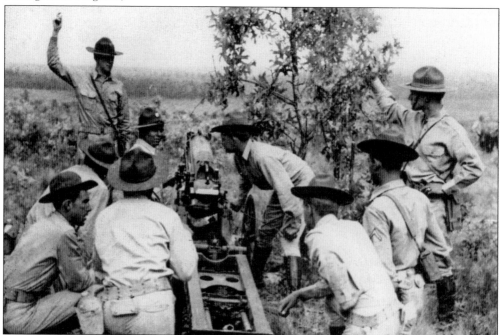

SOLDIERS IN THE FIELD, C. 1939. This photograph of Fort Bragg was taken around the spring of 1939. Field artillerymen load, aim, and fire a 75-mm Pack Howitzer M1. Typically served by a nine-man crew, this light artillery piece was originally designed to be dismantled for transport over rough terrain by six pack mules. Six additional mules were required to haul the ammunition and section equipment for each gun. (Courtesy of U.S. Army Fort Bragg Cultural Resources Management Program.)

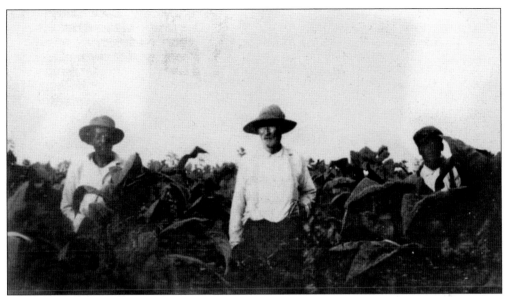

EARLY CULTIVATION. The sharecrop tenant system replaced the old plantation system. With the help of sharecroppers, the production of cotton and tobacco increased threefold. This picture, taken around the time Hoke County was established, illustrates Hoke's strong dependence on agriculture. Archibald A. Ray (center) is seen here with two unidentified tenant farmers in a tobacco field. (Courtesy of Richard Neeley.)

KING COTTON FLOAT. For many years, farmers in Hoke County depended on cotton as the key moneymaking crop, often referring to it as "king cotton." It is still a major crop in the county. This photograph illustrates the importance of cotton to the local community; a float in a parade decorated with cotton passes by the courthouse. (Courtesy of Hoke County Library.)

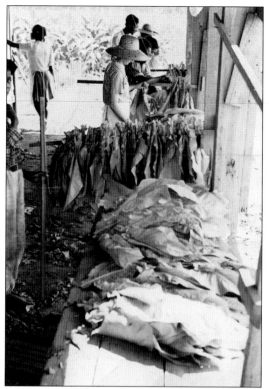

STRINGING TOBACCO. Tobacco is placed in drags or sleds, a homemade wooden crate that drags on the ground and was pulled by a mule, and brought to the barn. The barn crew places the tobacco on benches and one person on each side of the stringer hands the tobacco to a person who ties or strings the tobacco on sticks to be placed in the barn for curing. (Courtesy of Edith Newton.)

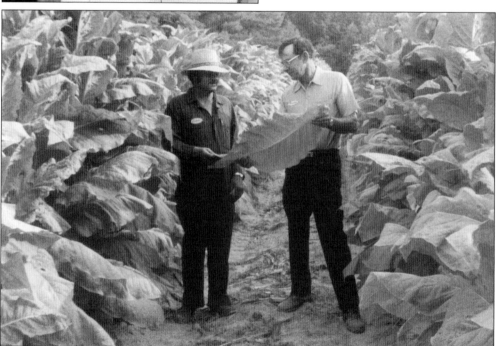

PERFECT TOBACCO LEAF. Edwin B. Newton and Calvin Lowery examine a perfect leaf of tobacco. To find an unflawed leaf without any holes is a joy to any tobacco farmer. Newton, known around town as Buddy, was named farmer of the year in 1954. (Courtesy of Edith Newton.)

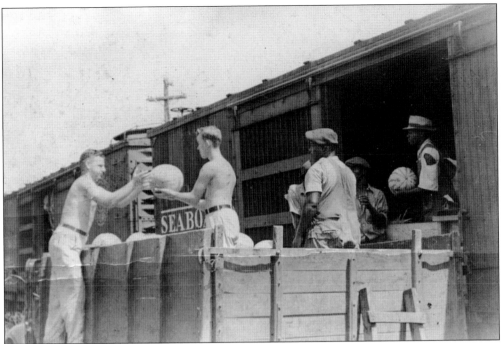

LOADING WATERMELONS ON THE TRAIN. Many farmers in Hoke County grew watermelons that were delivered to other states. The soil was excellent for growing the summertime fruit. Pictured here are DeVoe Austin and June Johnson loading watermelons for shipment. (Courtesy of Louise McDiarmid.)

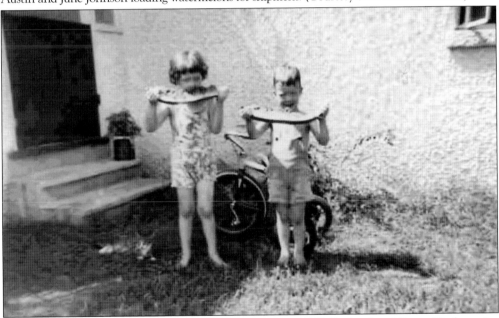

WATERMELONS IN SUMMERTIME. In this photograph from 1952, Richard and Susan Neeley enjoy watermelons from their parents' garden. They are photographed in front of a cinder block barn, which replaced the old wood barns on the farm. Summertime in Hoke County was spent with most children running barefoot, wearing shorts, and enjoying vegetables and fruits. (Courtesy of Richard Neeley.)

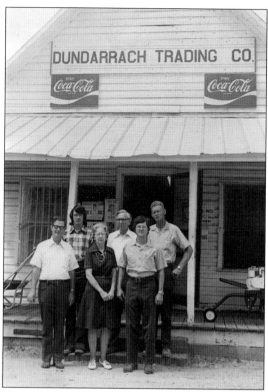

DUNDARRACH TRADING COMPANY EMPLOYEES. Employees of Dundarrach Trading Company were photographed in 1976, celebrating America's 200th birthday. From left to right are (first row) Tom Jones, Pauline Bruner, and Marty Jones; (second row) Kenny McInnis, Burnice Williamson, and Ronnie Davis.

DUNDARRACH TRADING COMPANY. Dundarrach Trading Company was established in 1911 by Dougald McLean and L. A. McInnis as a general store and gristmill for corn on the Aberdeen and Rockfish rail line at Dundarrach. Z. V. Pate Company bought the partnership in 1940 and expanded it into a soybean storage business.

David Smith, Hoke County Treasure. David Smith was a talented photographer and electronics specialist who watched and recorded the growth of the county. Many of the photographs contained in this book are his work.

Smith Plow Invented. James Peter Smith, father of David Smith, invented and produced the Smith Plow in Hoke County. He made the first one for himself, and people thought his idea was so fine that they came from near and far to get their own. He designed the manufacturing process and sold the plows for $40 per dozen.

WILLIAM JOHN MCNEILL, 1882. Addie Baker and William John McNeill married December 2, 1917. Born July 14, 1882, McNeill was the son of Edward Alexander McNeill and Sarah Margaret Campbell and was the oldest grandson of Archibald Black and Janie McEachern McNeill. His grandfather deeded him 50 acres of land, which he cleared with a team of mules. McNeill purchased more farmland throughout the years and continued to farm all his life. (Courtesy of Alona McNeill.)

GOLDEN KNIGHT, GENE PAUL THACKER. Gene was a member of the first Golden Knight Squad and was called the "Team Daddy." In 1967, he was honored as the first "Golden Knight of the Year." Gene and his son Paul Keith, who was called P. K., are pictured about to jump at Raeford Airport. P. K. died in a skydiving accident in Talequah, Oklahoma, practicing for the U.S. Nationals in 1973. The name of the Raeford Airport was changed to P. K. Air Park in his memory. (Courtesy of Gene Paul Thacker.)

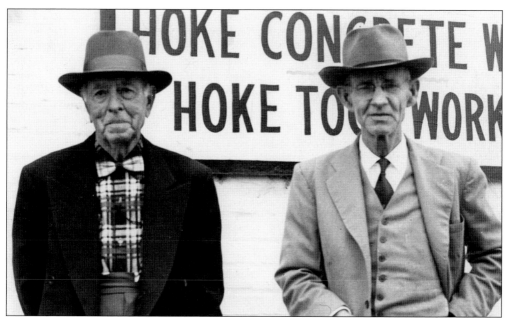

CAREY KELLY AND M. B. WARREN. Carey Kelly and M. B. Warren, both retired, were longtime employees of Hoke Oil and Fertilizer Company. Warren was hired as superintendent of the facility, a position he held until his retirement in 1969. Hoke Oil and Fertilizer Company was chartered in 1913. Johnson Concrete Company was formerly Hoke Concrete Works, a division of Hoke Oil and Fertilizer Company.

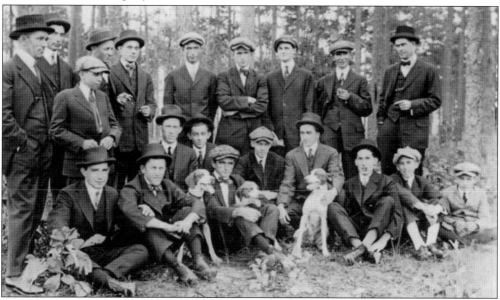

LOOKING BACK, 1914. This 1914 photograph shows some of Hoke County's young men. From left to right are (first row) Percy Thomas, Max Heins, Neill Sinclair, Will Moyle, Dan McKeithan, John Blue, Herbert McKeithan, Bert Nesbit, Neill McKeithan, and John McKoy Blue; (second row) Freddie Fridell, Malcolm ("Make") McKeithan, Tutts Heins, Will Heins, Ellis Williamson, Martin McKeithan, Lawrence Poole, John Walker, Fred Johnson, and Will Roberts. (Courtesy of Jim Sinclair.)

THE PARKER GIRLS. Willa Ray Parker (center) is pictured in the living room of the Parker house in the 1950s. From left to right are Grace Parker Boutwell, Christian Parker Jones, Willa Parker, Jessie Parker Neeley, and Caroline Parker. Willa, Jessie, and Caroline were lifelong residents of Hoke County. Caroline taught first grade in Hoke County School System for more than 30 years. (Courtesy of Richard Neeley.)

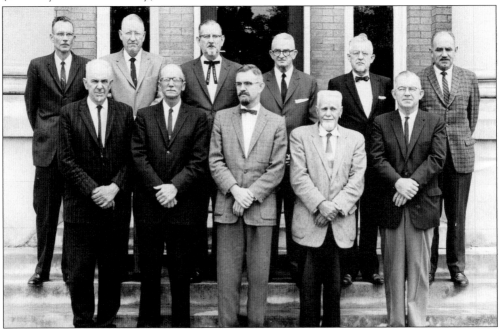

HOKE COUNTY OFFICIALS, 1961. Photographed are some of the county officials on the front steps of the courthouse. From left to right are (first row) county commissioners Lacy McNeill, C. C. Conoly, Dr. Julius Jordan, R. A. Smoak, and J. H. Blue; (second row) county manager T. B. Lester Jr., clerk of court M. D. Yates, tax collector Archie Byrnes, Sheriff D. H. Hodgin, register of deeds J. E. Gulledge, and school superintendent W. T. Gibson Jr.

JOHN E. MCGOUGAN, WOOD CRAFTSMAN. John E. McGougan was a farmer in Hoke County, and he took up whittling and woodworking to make use of idle time. He carved ducks, birds, and other Carolina critters and also built furniture, model airplanes, and dioramas of early farm life. Only after his death in early 2003 did McGougan's family realize the extent of his talent and the vast number of works he had produced over the years. As a tribute, the McGougan family donated some of his original artwork to the Raeford-Hoke Museum. (Courtesy of McGougan family.)

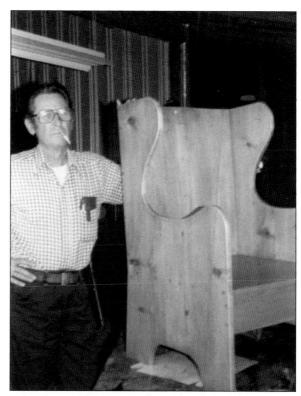

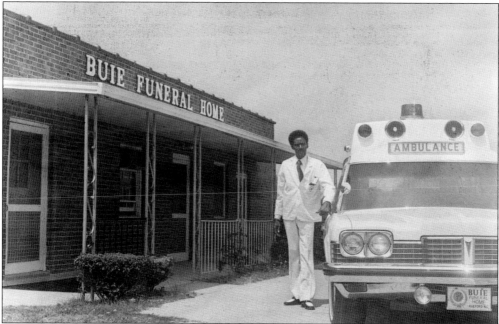

BUIE FUNERAL HOME. Edward Buie established Buie Funeral Home, the first African American funeral home in Hoke County, on Vass Road in 1922. Buie passed away in 1955 and his wife, Gloria, took over the business. Tony Buie, their son, joined the firm in 1970, and a chapel was added next door in 1976. The business is still in operation.

MARSHALL NEWTON, COUNTY COMMISSIONER. Marshall Newton, son of Hector Carlton Newton and Mattie Adrella Bennett and grandson of William P. Newton and Mary Cole Covington, is pictured here with his wife, Cleva Martin Newton, and their first child, Mildred. They were married in 1921 in St. Pauls, North Carolina. Marshall Newton was a farmer, businessman, and county commissioner. Cleva was involved in a variety of community activities. (Courtesy of Edith Newton.)

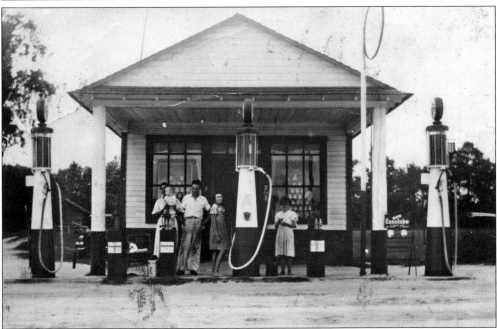

NEWTON STORE. Marshall Newton operated a grocery and gas station in the 1930s. It was located near Puppy Creek in Hoke County. Photographed in front of the general store are, from left to right, Mable Davis, holding one-year-old Buddy Newton; Lloyd Crowley; Mildred Newton; and Mary Catherine McInnis. (Courtesy of Edith Newton.)

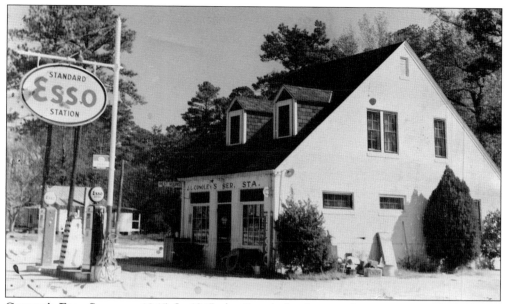

CONOLY'S ESSO STATION, 1945. In 1945, the Conoly family moved to a grocery and gas station located on Highway 15-A. Due to the poor health of James Lawrence, Ruby and her three sons helped run the general store. On May 2, 1952, Lawrence had a fatal heart attack. Jimmy Conoly continued operation of the store and later Earl Conoly joined him. That was the beginning of Conoly's Esso Station. (Courtesy of Joyce Monroe.)

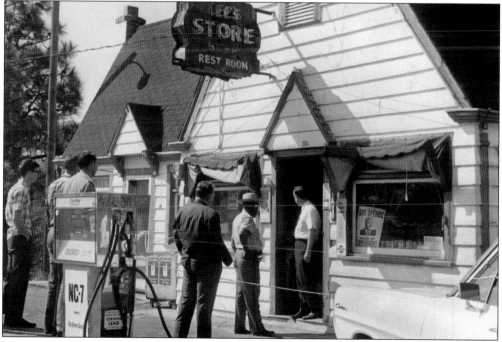

MARSHALL PARKS, RESTAURANT AND STORE. After Lee's store in Quewhiffle Township burned in 1968, the property was purchased by Marshall Parks, who restored it into a gas, grocery, and restaurant facility. When Parks died in 2008, his son Michael took over the business. Michael still operates the store today.

HOKE COUNTY JUBILEE QUEEN. Rosemary Cameron, daughter of Hubert and Mary Frances Conoly Cameron, of Raeford, won the title of Hoke County Jubilee queen. Cameron competed against nine other girls and was crowned by Gov. Terry Sanford at the opening of the jubilee drama *Hoke's Heritage*—a historical pageant that was held May 14–19, 1961, with local performers from all corners of Hoke County. (Courtesy of Joanne Reid.)

QUEEN ROSEMARY AND HER PAGES. During her weeks of reign as Jubilee queen, Rosemary Cameron said, "My only wish is for everybody to enjoy themselves." Two pages, Jennie Monroe, daughter of Harold and Joyce Monroe, and Sharon Conoly, daughter of Earl and Mary Frances Conoly, carried Rosemary's robe at all the activities she attended. (Courtesy of Joyce Monroe.)

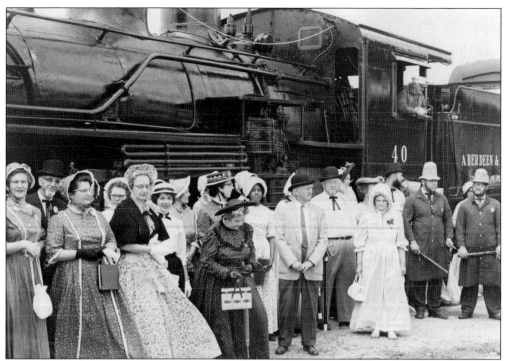

Jubilee Train Ride. "Jubilee Belles" and "Keystone Cops" rode the old Aberdeen and Rockfish Railroad train No. 40 from Raeford to Fayetteville during their activities. The train was a special treat provided by Forest Lockey, the president of Aberdeen and Rockfish Railroad in 1961. Participating ladies wore colonial attire, and men grew beards and wore top hats and bow ties.

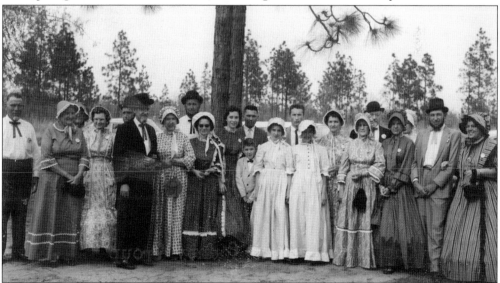

Brothers of the Brush (Because of their Long Beards). Photographed during the Golden Jubilee from left to right are Carl Riley and Mrs. Riley, Mrs. Ed Butler, Mrs. Robert Strother, Robert Strother, C. P. and Mrs. Satterwhite, Marcus and Mrs. Thompson, Doris Jane Thompson, Joe Smith, Harold Nixon, Peggy Nixon, Harold Thompson, Ann Nixon, Mrs. Leonard McBryde, Mrs. Paul Cloer, Fred Holloman, Nancy Cloer, Mrs. Fred Holloman, and James and Edith Nixon.

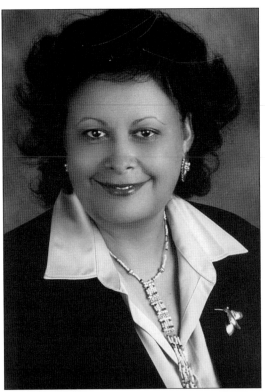

DELLA MAYNOR, REGISTER OF DEEDS.
Della Maynor is the daughter of Joseph and Eula Mae Maynor. She attended Hawkeye Elementary School and graduated from Hoke County High School in 1973. She became interested in politics, which led her to campaign and eventually be elected to the position of Hoke County Register of Deeds. She was the first Native American register of deeds in the state of North Carolina. (Courtesy of Linda Revels.)

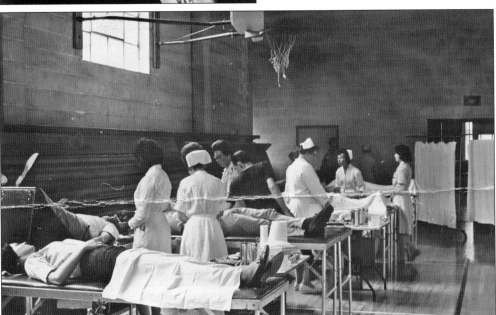

TONSIL CLINIC. A tonsil clinic was held in the high school gymnasium on June 1 and June 2, 1940. Throat specialist Dr. J. W. McKay, of Fayetteville, performed any operations and was assisted by local doctors. The clinic was held with special emphasis on preschool children. Well over 100 children registered for the clinic, which was coordinated by Mrs. H. A. Cameron, chairman of the welfare board of Hoke County.

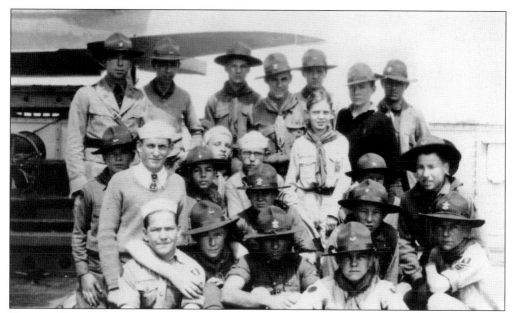

RAEFORD SCOUTS VISIT CRUISER. Members of the 1931 Raeford Scout Troop I pose here for a photographer on the deck of the crusier *Raleigh* during jamboree activities in Wilmington. Some of the Scouts pictured, in no particular order, are Clyde McInnis, Sam Snead, Nathan Epstein, Billy Crawley, Hubert Cameron, Tom Cameron, James Stevens, Malloy Lamont, Walter Barrington Jr., Younger Snead, Neill J. Blue, W. E. "Web" Blue, Jake Austin, E. L. Peele Jr., William McFadyen, Robert Ward Whitley, and Jack Morris (in light uniform).

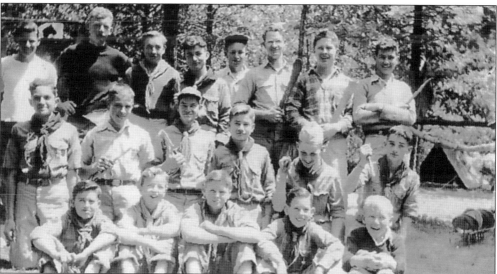

RAEFORD SCOUT AT CAMPOREE, 1947. Raeford Boy Scouts was organized in 1929. It was sponsored by the Raeford Kiwanis. F. B Sexton and Alfred Cole were first scoutmasters. From left to right are (first row) Avery Connell, Hal Gore, John McLauchlin, Franklin Teal, and Bobby Alexander; (second row) Milton Mann, Malcolm Glisson, Franklin Niven, Dave Barrington, Kenneth Clark, and Joe Gulledge; (third row) Bobby Murray, Locke MacDonald, Thomas Alexander, Carson Davis, Eugene Smith, Alton Clark, Johnny Sinclair, and Paul Johnson. Boy Scouts have continued to be a part of Hoke County history. (Courtesy of Jim Sinclair.)

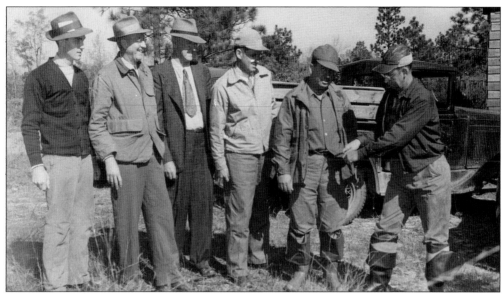

DEER HUNTERS. The deer must have gotten away from Harry Green. Judson Coats enjoys cutting Green's shirttail—a hunting tradition that marked a man who let his trophy get away because of a bad shot. Pictured are, from left to right, Judson Lennon, Bud McKeithan, John McGougan Robert Gatlin, Harry Green, and Judson Coats.

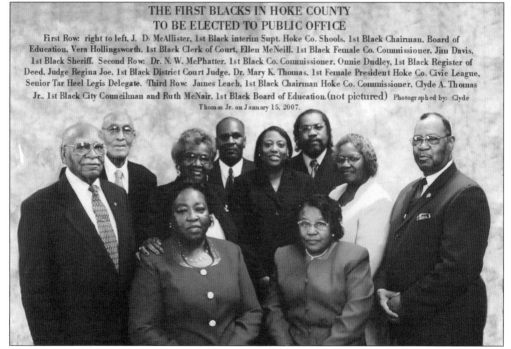

THE FIRST BLACKS IN HOKE COUNTY
TO BE ELECTED TO PUBLIC OFFICE
First Row: right to left, J. D. McAllister, 1st Black interim Supt. Hoke Co. Shools, 1st Black Chairman, Board of Education, Vera Hollingsworth, 1st Black Clerk of Court, Ellen McNeill, 1st Black Female Co. Commissioner, Jim Davis, 1st Black Sheriff. Second Row: Dr. N. W. McPhatter, 1st Black Co. Commissioner, Onnie Dudley, 1st Black Register of Deed, Judge Regina Joe, 1st Black District Court Judge, Dr. Mary K. Thomas, 1st Female President Hoke Co. Civic League, Senior Tar Heel Legis Delegate. Third Row: James Leach, 1st Black Chairman Hoke Co. Commissioner, Clyde A. Thomas Jr., 1st Black City Councilman and Ruth McNair, 1st Black Board of Education.(not pictured) Photographed by: Clyde Thomas Jr. on January 15, 2007.

FIRST AFRICAN AMERICANS ELECTED TO PUBLIC OFFICE. Photographed are the first African Americans in Hoke County to hold public office. From left to right are (first row) John D. McAllister, Vera Hollingsworth, Ellen McNeill, and Jim Davis; (second row) Neal Wesley McPhatter, Onnie Dudley, Regina Joe, and Mary K. Thomas; (third row) James Leach and Clyde Thomas Jr. (Courtesy of Ellen McNeill.)

HOKE MOTHER OF THE YEAR, 1963.
Florrie Cameron helped to establish "soup kitchens" in all the schools of Hoke County during the 1920s. In 1924, while serving as president of the County Council of Parents-Teachers Association, Cameron instituted and promoted the idea of serving hot soup to all of Hoke County's hungry schoolchildren. By 1928, every school child in the county received a free bowl of hot soup for lunch. (Courtesy of Joanne Reid.)

CAMP ROCKFISH DEDICATION. Upchurch Milling Company donated a cabin at Camp Rockfish in honor of Florrie Upchurch Cameron. This photograph was taken at the dedication ceremony. Cameron is pictured sitting, and from left to right standing behind her are (first row) Marie C. Brown, Evelyn Brown, and Diane Upchurch; (second row) Robert B. Lewis, Anne Hoyl Upchurch, Maude Upchurch Lewis, Bennie Lee Upchurch, Emily Breeden Cameron, Agnes Upchurch Johnson, Alice Johnson Upchurch, Clyde E. Upchurch, and Tom U. Cameron. (Courtesy of Joanne Reid.)

JOHN ANGUS HODGIN, 1867–1959. John Angus Hodgin, a native of the Antioch community, was a farmer who also owned a general store. After Hoke County was formed in 1911, Gov. R. B. Glenn named Hodgin to the first board of education. He served in the North Carolina General Assembly as Hoke's first representative from 1917 to 1919.

COUNTRY DOCTOR R. A. MATHESON, M.D. (1898–1960). In 1928, Dr. Robert Arthur Matheson purchased medical equipment from Dr. K. B. Geddie of Raeford and began serving the local community. With the nearest hospital 20 miles away, Matheson compassionately and expertly treated his patients with a broad spectrum of medicine. (Courtesy of Alice M. Stanback.)

JAMES ALBERT HUNT, COUNTY COMMISSIONER. James Albert Hunt, who was in the trucking business, served as a Hoke County commissioner. Pictured are James Albert Hunt, his wife, Maggie, and their children, Jackie, Bobby Jean, and Sam.

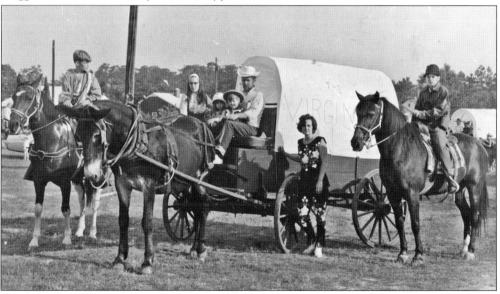

HOKE COUNTY WAGON TRAIN. The wagon train is an annual affair in Hoke County that began 47 years ago. Horses and wagons meet in Raeford and travel down Main Street before going to a special campground. The event is a weekend family get-together during which children play games while adults enjoy music and dancing. Horse races, barrel races, and other activities are also held. Pictured here is a family getting ready for the ride down Main Street.

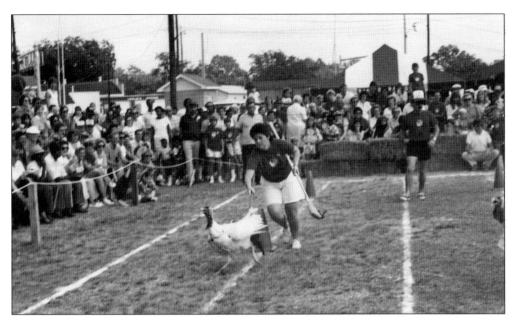

FIRST NORTH CAROLINA TURKEY FESTIVAL, 1985. Hoke County hosted its first North Carolina Turkey Festival in 1985. Included in the list of events were turkey-cooking contests, a parade, a variety of turkey meals, and plenty of music—all of which were enjoyed by thousands of happy people. A turkey-racing contest was held that permitted contestants to keep their turkeys in line using a broom (Shelia Black is pictured here), but that event has since been cancelled. Turkey lovers continue to enjoy this festival today.

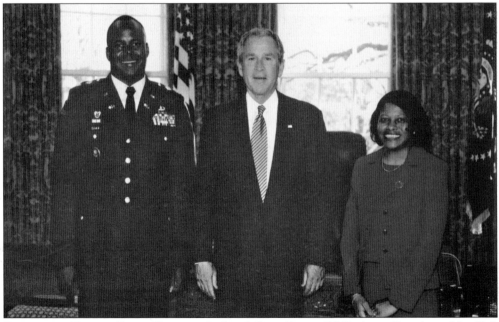

PAMELA AND DARRYL SHAW. Photographed with Pres. George W. Bush are Pamela and Lt. Col. Darryl Shaw, who served as the commander of the 2nd Presidential Communications Command Oval Office of the White House in 2004. Pamela, a native of Hoke County, is the daughter of Willie and Ellen McNeill of Raeford. (Courtesy of Ellen McNeill.)

Three

AROUND TOWN

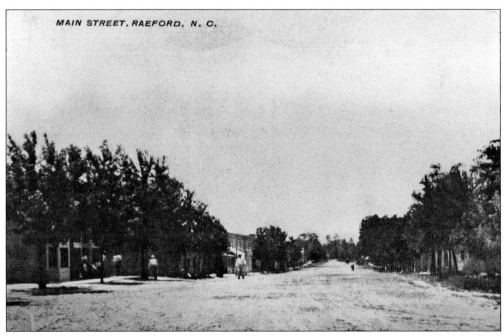

MAIN STREET, RAEFORD, N. C.

RAEFORD INCORPORATED. The small village of Raeford was incorporated by the North Carolina General Assembly in 1901. According to the original census there were about 116 households in the area. There were only a few buildings, and the dirt main street was wide enough for a horse and wagon to turn around without having to back up. (Courtesy of Raeford-Hoke Museum.)

HOME FOOD SUPER MARKET, 1930. In this photograph, John K. McNeill Sr. and F. B. Sexton are repairing a wagon wheel. McNeill dreamed of operating a grocery store; his first love was selling groceries. John and his brother N. A. McNeill opened McNeill's Grocery on Main Street. The store had its ups and down. Today it is the Home Food Super Market, and it is believed to be the oldest grocery store in Raeford. (Courtesy of Louise McDiarmid.)

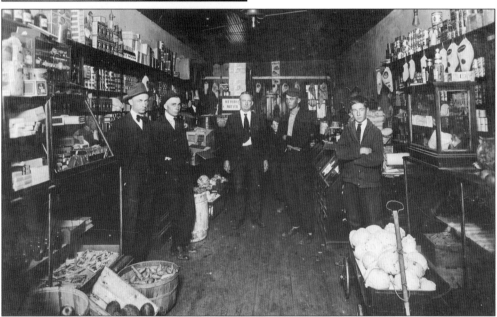

HOKE'S OLDEST GROCERY STORE. This old photograph was taken inside McNeill's Grocery. Pictured are, from left to right, John K. McNeill Sr., Evander Gillis, Tom Conoly, and the others are unidentified. Sometime in the mid-1930s the store's name was changed to Home Food Super Market. It was through this set-up that the McNeill boys were exposed to merchandising. (Courtesy of Luke McNeill.)

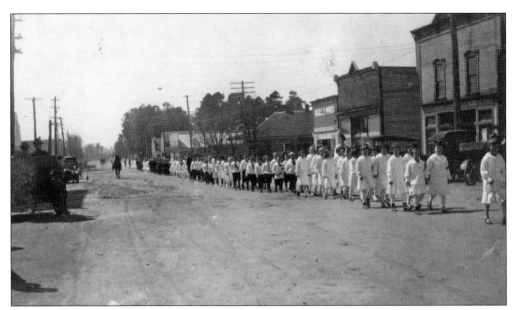

PARADE DOWN MAIN STREET, 1916. People moved into the area to educate their children. A large number of children can be seen here attending Raeford Graded School. Because the number of students and cars on the street was plentiful, an ordinance was passed that prohibited cars from going more than 10 miles per hour in the business district and more than 18 miles per hour in the residential section.

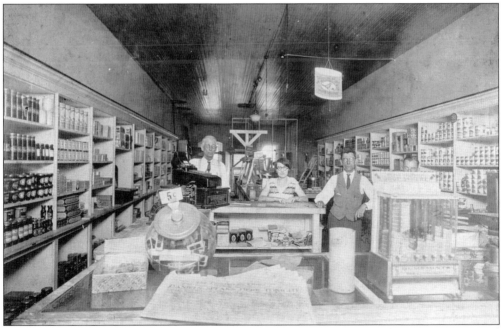

HOME PRIDE GROCERY, 1920. James Edwin Conoly, proprietor of Home Pride Grocery, is pictured here with two of his children. From left to right are employee J. A. Wilson, daughter Etta Conoly Taylor, Conoly, and son James Lawrence Conoly. This store was located on Main Street, though Conoly eventually moved it to a side street and later to East Prospect Avenue. (Courtesy of Letitia Conoly.)

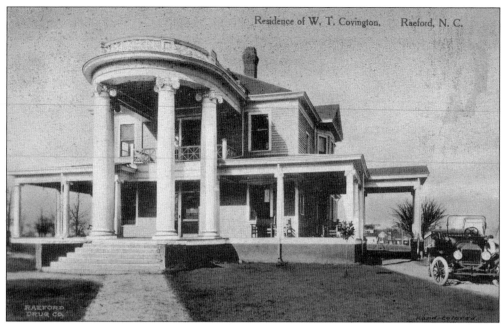

W. T. COVINGTON HOUSE. Originally a farmhouse, the W. T. Covington house was built in 1912 using longleaf pine lumber. Located in the backyard were several farm buildings, pastures, a chicken yard, and vegetable garden. Brick pillars along the streets were added later. Covington died in 1934, and the house was sold in 1963. (Courtesy of North Carolina Collection, University of North Carolina Library at Chapel Hill.)

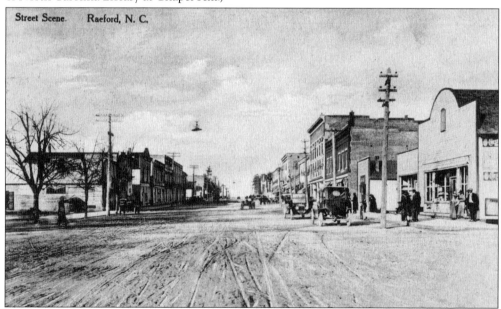

LIVERY STABLES, A NECESSITY. This 1905 photograph shows a livery stable that boarded horses and kept horses and carriages for hire. Other businesses were the backbone of farming, lumbering, transportation, and many other uses. These businesses were the dealers in livestock, wagons, buggies, surreys, and blacksmith shops. (Courtesy of North Carolina Collection, University of North Carolina Library at Chapel Hill.)

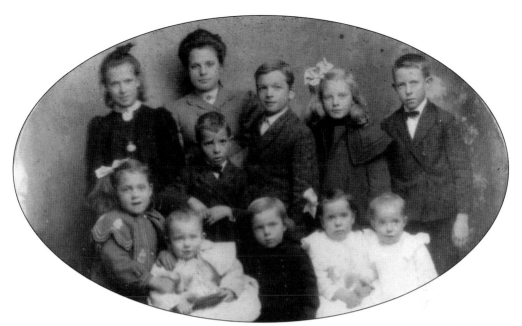

CHILDREN OF THOMAS BENTON AND WILLIAM J. UPCHURCH, 1904. Photographed are the children of the Upchurch brothers, Thomas Benton and William J. The children are (first row) Bennie Lee, 4; Lawrence, 4 months; Tommy, 2; Mae, 3; and Lucille, 1; (second row) Worth, 6; (third row) Agnes, 10; Florrie, 12; Clyde, 10; Maude, 8; and Staley, 8. Thomas Benton's children are Florrie, Clyde, Maude, Bennie Lee, Tommy, and Lawrence; William J.'s children are Agnes, Staley, Worth, Mae, and Lucille.

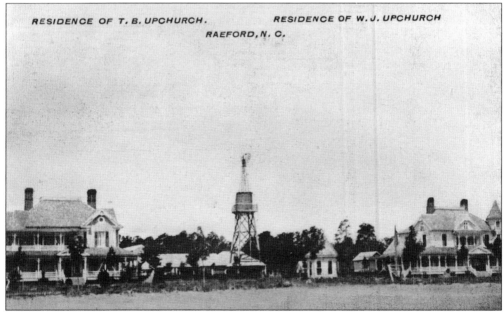

UPCHURCH HOMES, 1905. Brothers Thomas Benton Upchurch and William J. Upchurch built these identical houses on Main Street in Raeford. The Upchurchs moved to Raeford in 1899, where they continued their sawmill and lumber business. (Courtesy of North Carolina Collection, University of North Carolina Library at Chapel Hill.)

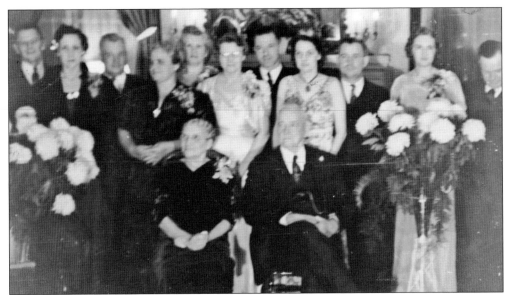

Thomas Benton and Mollie Upchurch, Anniversary. Children and their spouses celebrated the golden anniversary of their parents, Thomas Benton and Mollie Johnson Upchurch. Pictured from left to right are (seated) Mollie Johnson Upchurch and Thomas Benton Upchurch; (standing) Alan and Bennie Lee McGee, Clyde Upchurch Sr., Alice Upchurch, Florrie Cameron, Maude Upchurch, Bob Lewis, Anne and Tommie Upchurch, and Mary and Lewis Upchurch. Thomas Benton married Mollie in 1889. (Courtesy of Joanne Reid.)

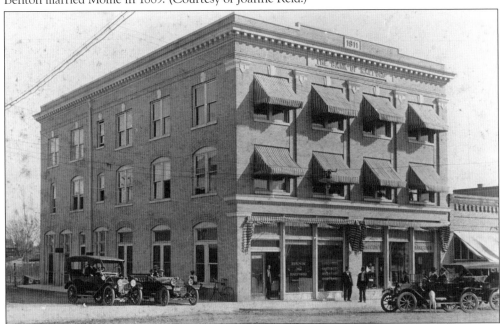

The Bank of Raeford, 1903. The Bank of Raeford was organized on May 1, 1903, and the first president was John Blue. The bank opened for business on October 6, 1903, as Raeford's first bank institution. The building pictured above was constructed in 1911. A new building was completed in 1979 and is operated today as Branch Banking and Trust Company. (Courtesy of Joyce Monroe.)

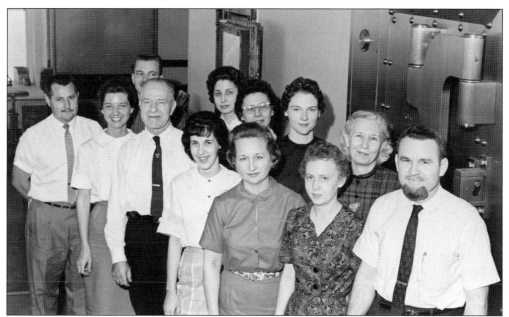

BANK EMPLOYEES, 1961. Hoke County residents, including the bank employees in this photograph, celebrated the county's 50th birthday in 1961 with a special jubilee program. From left to right are (first row) Robert L. Conoly, Inez Maxwell, Robert B. Lewis, Peggy Wilkes, Sarah Maxwell, Joyce Conoly Monroe, and Wilton Wood; (second row) Jimmy Hedgepeth, Dorene Cothran, Clara Mewherter, Peggy Sumner, and Jessie B. Ferguson. (Courtesy of Joyce C. Monroe.)

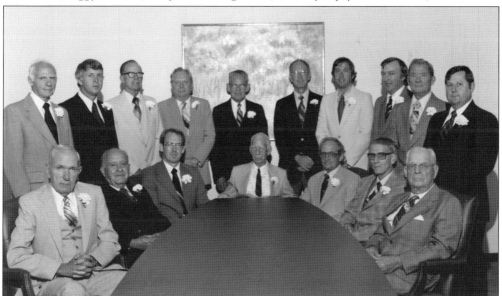

BANK DIRECTORS, 1979. The board of directors of the Bank of Raeford pose around a conference table. They are, from left to right, (seated) Thomas F. McBryde, Bernard Bray, William E. Carter, Lawrence McNeill Sr., Tom Cameron, John W. McPhaul, and Thomas B. Upchurch Jr.; (standing) Jake Austin, James B. McLeod, Edwin D. Newton, William L. Howell Jr., Hallie L. Gatlin, William L. (Bill) Moses, Julian Johnson Jr., Neill A. McDonald III, Denver R. Huff, and Robert L. Conoly. (Courtesy of Joyce Monroe.)

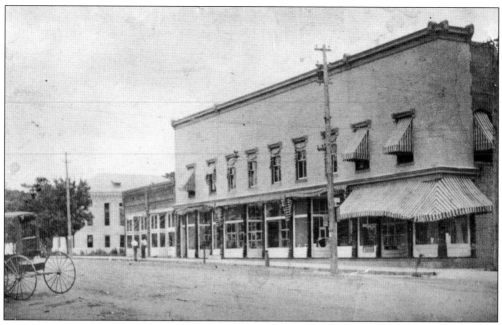

OLDEST BUSINESS IN RAEFORD, 1900. McLauchlin Company, which is believed to be the oldest business in Raeford, started as a country store and grew into a large operation. Founder John W. McLauchlin operated the country store at old Raeford, near Rockfish Creek, before deciding to open a store in the new school village. The original building burned and the business moved to another location before it closed. (Courtesy of Raeford-Hoke Museum.)

FACTS AND FIGURES. David Scott Poole began publishing Raeford's first newspaper, *Facts and Figures*, in 1905. He is pictured here, at left, with Sheriff Edgar Hall. F. P. Johnson purchased the newspaper in 1911 and changed the name to the *News-Journal*. Paul Dickson Sr. started another newspaper in 1928 called the *Hoke County News*, which he eventually consolidated into the *News-Journal*.

Paul Dickson Jr., a Great Boss. Paul Dickson Jr. served his country during World War II and returned home to become editor of the *News-Journal* in 1946. Connie F. Ellis, a former employee of Dickson, describes him as a wonderful boss and a "joy to work with for 43 years." Ellis recalled that he always said, "You did a great job"—a great motivator for any employee. (Courtesy of Connie F. Ellis.)

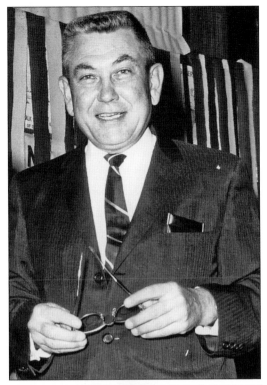

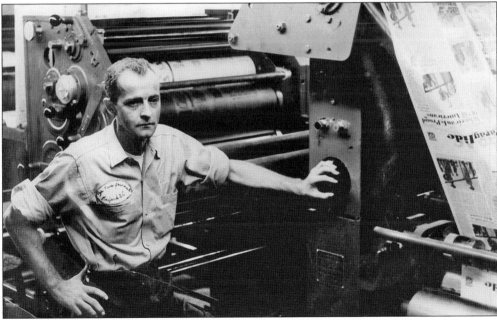

The News-Journal, 1929. Paul Dickson Sr. purchased *Facts and Figures* and changed the name of the newspaper to the *News-Journal*. The media source has been a constructive force in the life and growth of the county and community. The *News-Journal* was also a pioneer in the offset printing process. Shop foreman Jesse Peoples is photographed here with his hand on the throttle of the offset press.

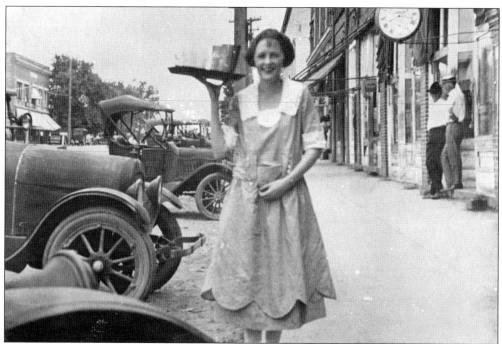

HOKE DRUG, CURB SERVICE. Hoke Drug Company was purchased by Walter Baker and his partner, L. E. Reaves, in 1924. Eventually, Baker bought the business from his partner. A new soda fountain was installed, and in this photograph a young lady carries sodas to a parked car sometime during the 1920s.

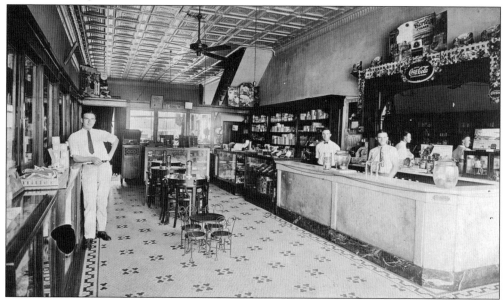

OLDEST BRICK STORE, 1911. Hoke Drug Company dates back to 1911 when the McPherson Brothers Drug Company opened in the C. J. Benner building. In 1912, it moved to the corner of Main and Elwood Streets and S. P. McPherson and Frank S. Blue renamed it Hoke Drug Company. Pictured is drugstore owner Walter Baker, left. Behind the counter are Roy Baker (front) and an unidentified young man. (Courtesy of Phyllis Baker McNeill.)

COLE'S FEED STORE, 1951. Cole's Feed Store purchased the grocery line from McLauchlin Company in 1951. Curtis Hardin managed the general grocery store, which sold fresh fish, vegetables, and meat. The store offered a place to sit and chat, like the gentleman in this photograph. It was destroyed in a fire.

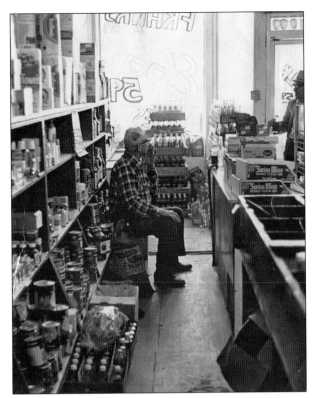

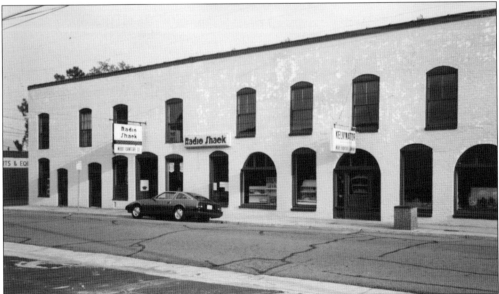

WOOD'S FURNITURE STORE. Originally built for Hines Telephone Company in 1906, the building was purchased in 1943 by J. Luther Wood, a used furniture salesman. In 1945, his son Kermit Wood Sr. joined the business and new furniture, appliances, and hardware were added. Grandson Kermit Wood Jr. joined the business in 1958. The Radio Shack franchise was brought to the company in 1976, and in 1990, the entire business relocated to Harris Avenue and operated as Radio Shack. (Courtesy of Kermit Wood Jr.)

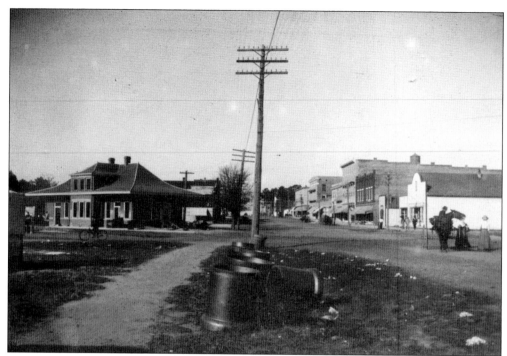

TOWN OF RAEFORD LIGHTS, 1909. A resolution was passed at a town council meeting to install electric wires and poles throughout Raeford. Electricity was available before dawn and after sunset. The lights were first illuminated on January 26, 1910. (Courtesy of Raeford-Hoke Museum.)

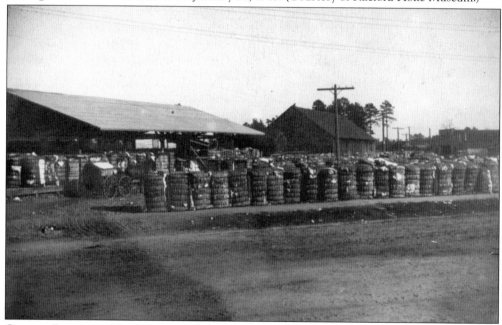

COTTON PLATFORM. The cotton platform was photographed in 1912 with many bales of cotton ready to be shipped. At times, there were wagons of cotton lined up along Main Street, waiting to be unloaded. Since cotton was the main cash crop, farmers would have a log rolling to clear fields of pine trees so the land could be used to plant cotton. (Courtesy of Raeford-Hoke Museum.)

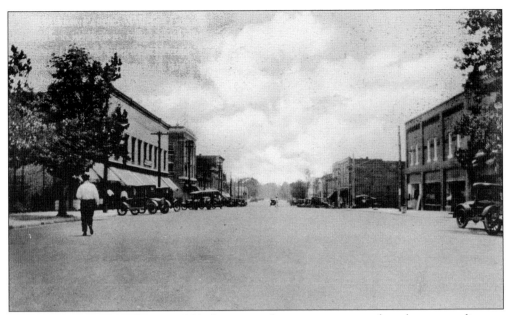

MAIN STREET LOOKING SOUTH, 1923. As more and more cars were purchased, a town ordinance was adopted on July 2, 1923, that required automobiles to park in white squares on the sides of streets and to only turn at intersections. On October 1, 1923, an ordinance passed mandating all automobiles use two headlights after dark.

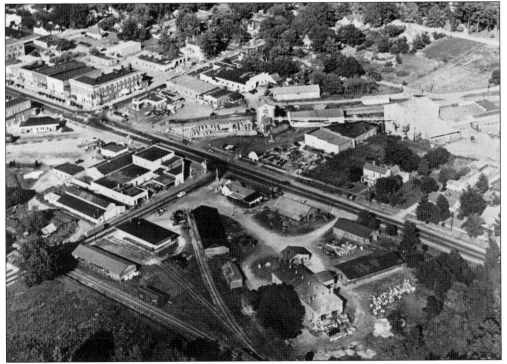

AERIAL VIEW OF RAEFORD, 1957. This aerial view of Raeford, looking south, shows the old cotton platform, Raeford Hotel, Upchurch Milling and Storage Company, Aberdeen and Rockfish Railroad crossing, and Robert L. Carter's Esso Station in the center, at the intersection.

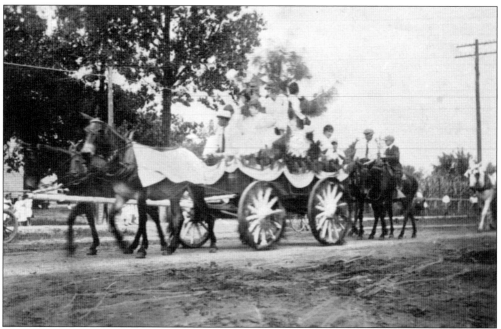

RAEFORD PARADE, 1916. Spectators gathered to watch floats pass by during the Raeford Parade of 1916. A town ordinance set on September 4, 1916, stated that during the parade profane language, disorderly behavior, and drunkenness were prohibited.

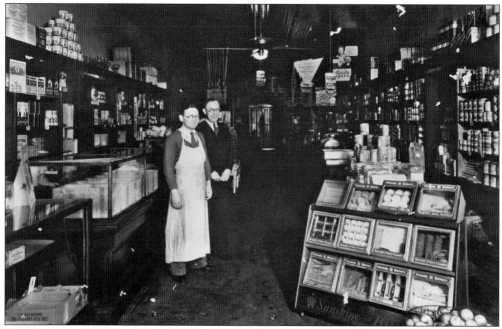

CAMPBELL AND COMPANY. From 1881 to 1948, Milton Campbell was the owner and operator of Campbell and Company grocery business located on Main Street in Raeford. Campbell is pictured here, at right, with Worth Campbell. Groceries were delivered by horse and wagon, and weddings were occasionally performed in the back room of his store. Campbell helped many families during the Depression by providing groceries to those who were unable to pay.

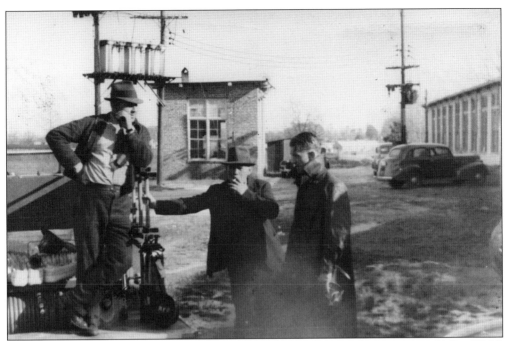

RAEFORD COTTON MILL FIRE. Pictured from left to right are Neill A. McDonald Sr., W. H. McLean, and Alfred Cole. The Raeford Cotton Mill caught on fire while they were the firemen on duty. (Courtesy of Louise McDiarmid.)

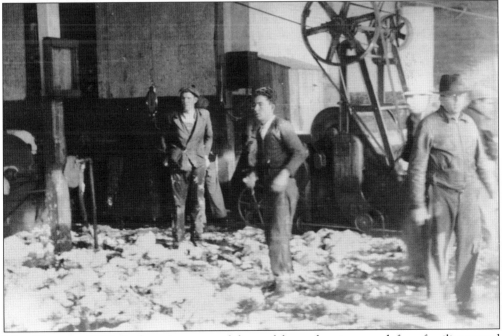

MILL VILLAGE, 1907. As factories grew and demand for workers increased, farm families moved to the mill villages. William J. Upchurch and Thomas B. Upchurch Sr. established Raeford Cotton Mill, which was located on the same tract of land where Raeford Burlington Industries now stands. (Courtesy of Louise McDiarmid.)

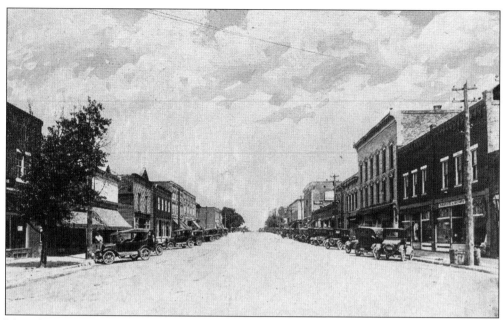

MAIN STREET FIRE. This photograph was taken before the Main Street fire of 1925. It depicts many of the businesses on Main Street, most of which were made out of wood, so they burned quickly. Fire trucks from several towns responded to the call in an effort to save the town of Raeford. (Courtesy of North Carolina Collection, University of North Carolina Library at Chapel Hill.)

DISASTROUS FIRE, 1925. A disastrous fire almost wiped out the entire downtown area of Raeford. Immediately after the fire, the mayor ordered a fire truck with a pump and chemicals from LaFrance's fire engine company. It is believed that the fire originated with an explosion in the Nesbit and Howell Dry Goods Store. Soon everything from the location of Hoke Drug Company to Central Avenue was burning.

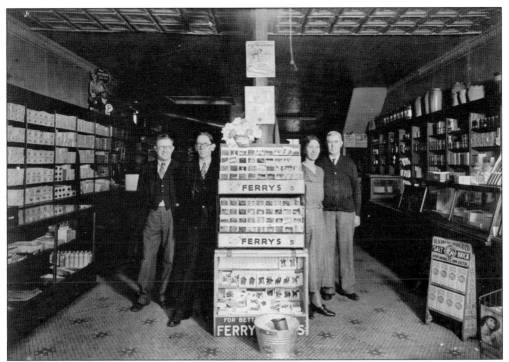

FARMER'S FURNISHING COMPANY, 1923. B. R. Gatlin started the general store called Farmer's Furnishing Company, and later his son Hallie Gatlin joined him in the business endeavor. Photographed inside the store are, from left to right, Neill B. Sinclair, Hallie L. Gatlin, Beatrice Sinclair, and Mack McDiarmid. (Courtesy of Jim Sinclair.)

FARMERS FURNISHING COMPANY, OUTSIDE VIEW. Dr. Graham used part of the Farmers Furnishing Company building for an office in 1915. Standing outside are, from left to right, Beatrice Sinclair, B. R. Gatlin, Dr. George A. Graham, J. J. Stafford, Neill B. Sinclair, and N. McL. McDiarmid. (Courtesy of Jim Sinclair.)

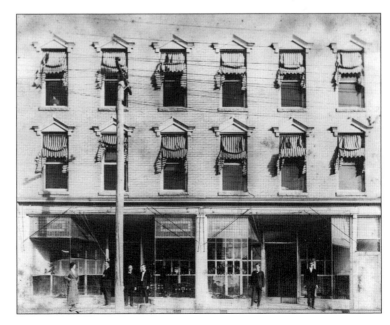

I. Mann Department Store. In 1921, Israel Mann left his home country of Lithuania and traveled to the United States. Four years later, he opened a clothing store on Main Street in Raeford, which he operated until his death. The first floor of the business was designated for menswear and overseen by Mann. The second level offered women's and children's apparel and was managed by his wife, Ruth.

Upchurch Milling Company, 1917. The Upchurch Milling Company was a small flour mill in 1917. By 1919, it added a gristmill, and in 1924, the company went into the ice manufacturing business. Later the company also manufactured mixed feed. It was located where Branch Banking and Trust Company is today.

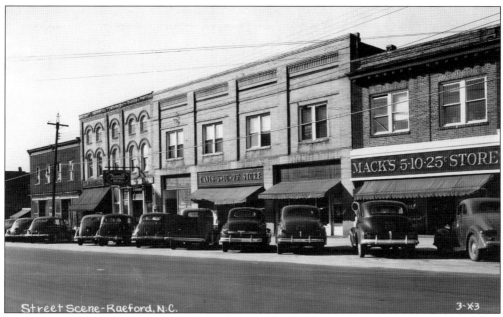

WEST SIDE OF MAIN STREET, 1930–1949. This photograph shows some of the businesses on Main Street during the 1930s and 1940s. Visible storefront signs were Rexall Drug Company (which became Howell Drug Company), a barbershop, Davis 5-10-25¢ Store, and Mack's 5-10-25¢ Store. (Courtesy of North Carolina Collection, University of North Carolina Library at Chapel Hill.)

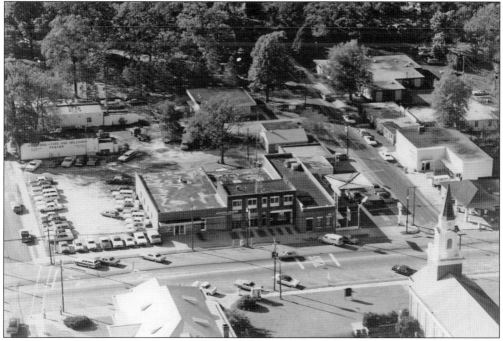

MAIN STREET LOOKING WEST, 1960S. This aerial photograph of Raeford shows the old city hall, old fire station, and Hugh A. Gardner's service station on the corner. The Raeford United Methodist Church is shown from the back. Other businesses on the side street are Dr. Julius Jordan's and Dr. Riley Jordan's offices and Raeford Savings and Loan Association's office.

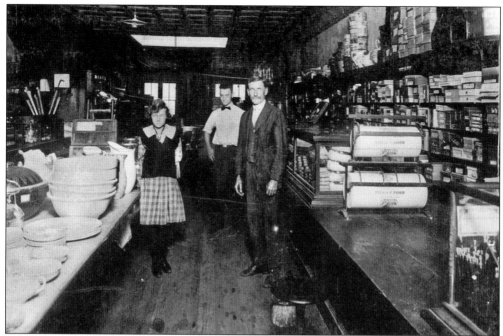

B. F. Moore General Store. B. F. Moore's general store was located on Main Street in Raeford in the early 1900s. Its specialties were housewares and general hardware. Pictured inside the store are, from left to right, Frances Bennette Moore, J. B. Hewitt, and B. F. Moore.

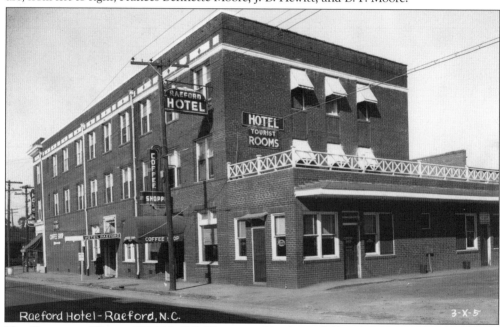

New Bluemont Hotel, 1927. Neill S. Blue opened his beautiful hotel on Main Street on March 24, 1927. The hotel had a lovely dining room where buses stopped for their passengers' meals. Through the years, the hotel changed owners and the name was switched to Raeford Hotel. The building was demolished in 2005. (Courtesy of North Carolina Collection, University of North Carolina Library at Chapel Hill.)

ATTORNEY AND JUDGE ARTHUR D. GORE (1886–1958). Arthur D. Gore came to Raeford in 1915 to practice law. He was a graduate of Wake Forest University in Winston-Salem and Columbia Law School in New York. Gore was elected as judge of recorder's court and also served as county and city attorney. In addition, he was an expressive and published writer. Gore practiced law until his death in 1958. (Courtesy of Anne Gore Register.)

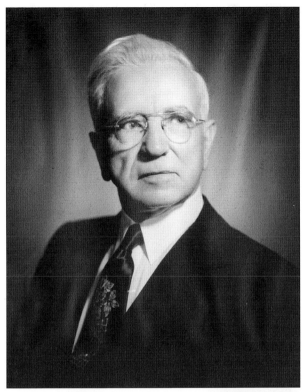

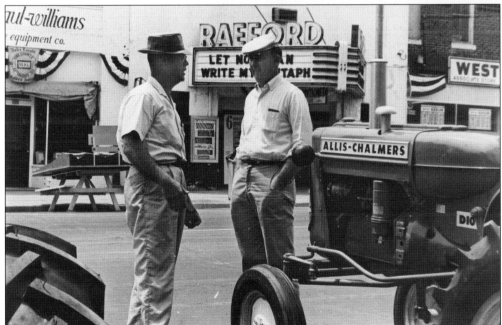

RAEFORD THEATER, 1930–1950S. Two unidentified men stand in front of the Raeford Theater during the Diamond Celebration of Hoke County. John Black McIntyre owned and operated the theater in the 1930s, 1940s, and 1950s. It was located where the Century Bank parking lot is now. Raeford Theater suspended operations in July 1955.

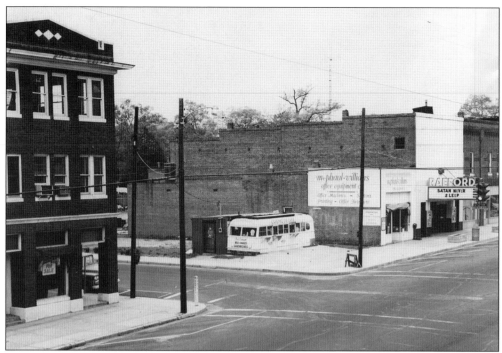

THE LITTLE RED WAGON. The trailer was located on Main Street in the 1930s and early 1940s. It is where one could take their pennies and buy "Mary–Jane's" bubble gum and Nehi Orange drinks. In November 1963, Southern National Bank opened for business on the site that was once occupied by the Little Red Wagon and McPhaul and Williams Company.

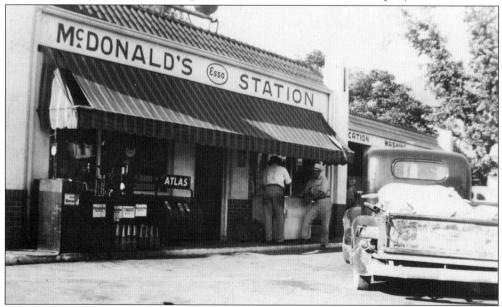

McDONALD'S ESSO STATION, 1937. In 1940, Raeford Oil Company bought the Esso Service Center on Central Avenue from J. B. Thomas, who built the station in 1937. The service center was McDonald's Esso, later Conoly's Esso, and is now Daniel's Pure Oil Station. It is still operated by Charles and Brian Daniels.

THE GULF STATION DEER. Atop the roof of Graham's Service Station sat a familiar sight. Two deer, sculpted by local artist W. T. Covington, were mounted there in the early 1930s. Decorated every Christmas, the deer resided on their rooftop perch until the business changed hands and they were given to the Hoke County High School, whose mascot is the buck. (Courtesy of Lib Wilson.)

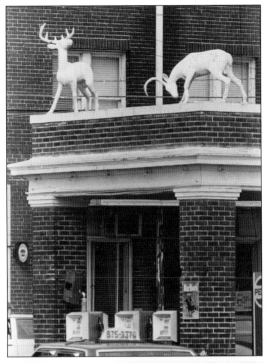

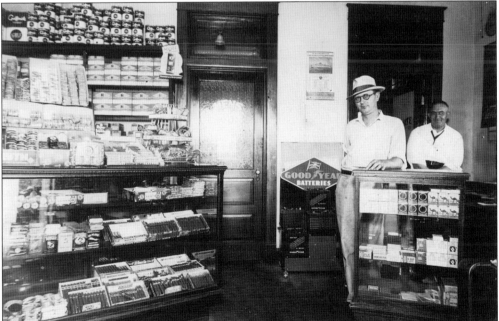

GRAHAM'S SERVICE STATION. A. A. Graham opened this landmark filling station at the corner of Main Street and Central Avenue in the summer of 1933. In this photograph, Graham (left) and an unidentified man are pictured inside the station. Graham ran the filling station until his death in 1964, after which his wife, Ila, operated it for several more years. In 1970, longtime employee Douglas B. Nixon purchased the station and managed it for years. Later a convenience store chain purchased the business and operates it today. (Courtesy of Lib Wilson.)

RAEFORD FURNITURE COMPANY. Sap McLean and a Mr. Kirkpatrick, a lawyer, have their photograph taken while sitting on the sidewalk in front of Raeford Furniture Company, a new enterprise in town. The business originated in the location formerly occupied by Freeman Furniture Store. Raeford Furniture Company was owned by Hallie L. Gatlin Sr. and Hallie L. Gatlin Jr., who later managed the store. For many years, the company donated miniature cedar chests to all graduating seniors of Hoke County High School. (Courtesy of Louise McDiarmid.)

THE COOL WATERS OF ROCKFISH CREEK. Rockfish Creek was the gathering place for young people as far back as the 1930s and maybe even before. On a hot day nothing felt better than cooling off with friends at Rockfish Creek.

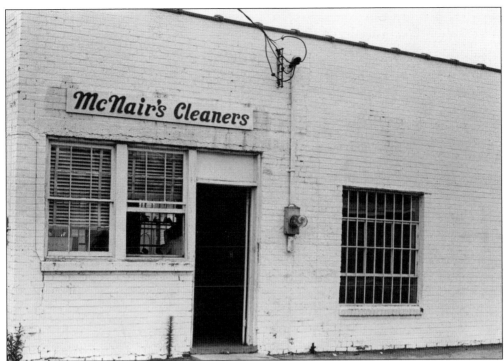

IVERY McNAIR, McNAIR'S CLEANERS. McNair's Cleaners opened its doors on April 1, 1936. Ivery McNair started the business after buying out John Hurst's cleaning shop on Racket Alley. McNair, a Raeford native, worked for Hoke Oil and Fertilizer Company before going into business for himself. He was a Mason, Shriner, and member of the Downtown Merchants Association and served as a director of the chamber of commerce.

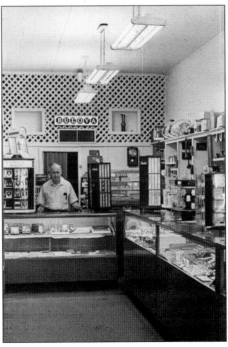

C. P. KINLAW'S JEWELRY STORE. Clarence P. Kinlaw came to Raeford in March 1939 and opened the C. P. Kinlaw Jewelry store. He went into military service in 1944, and his wife helped manage the store until her death. Clarence then married Dorothy Watson Kinlaw, and she operated the store after his death in May 1993. Charles Davis, a longtime employee, is photographed inside the jewelry store.

WORLD WAR II. Many men and women from Hoke County served in different branches of the military during World War II and other engagements. The National Guard of Raeford was called into action during the Second World War. Pictured are Clarence Willis and Jessie Gulledge looking over plans.

HOKE COUNTY'S NATIONAL GUARD. The Hoke County National Guard has three former members who retired with service in both world wars: Col. Robert B. Lewis, Lt. Col. William L. Poole, and Maj. J. H. Blue. Pictured are six of the Hoke County citizens who served in World War I. From left to right are William Lamont, Alfred Cole, Ernest Haire, T. B. Lester, Neill L. McFadyen, and Cliff Conoly.

ROSA'S GRILL MAIN STREET. Rosa's Grill on Main Street opened for business on November 22, 1969, under the ownership of perky Rosa Flowers. Years ago, the small building contained a hot dog stand. It has been used as an insurance office and at one time was a restaurant named McNeill's Grill. Flowers did the cooking with the help of her children. It was a cozy spot with a counter and a few tables.

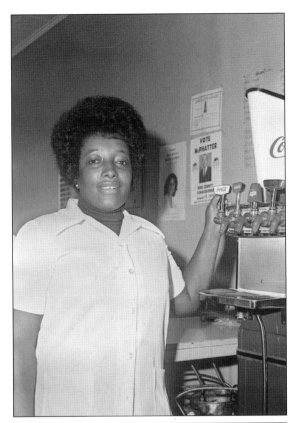

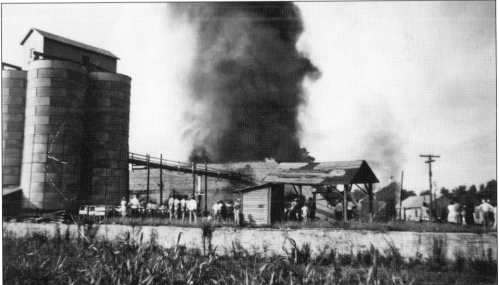

UPCHURCH MILLING COMPANY BURNING. Upchurch Milling Company, one of the oldest industries in Hoke County, burned in 1946. This photograph shows smoke from the smoldering building. The plant was rebuilt under the management of Tom Cameron and operated for several years. In 1978, Upchurch Milling Plant was destroyed, and the Bank of Raeford built a new office there that is now the Branch Banking and Trust Company.

GREAT ATLANTIC AND PACIFIC TEA COMPANY, 1919. W. L. Alexander managed the Great Atlantic and Pacific Tea Company until he retired in 1957. For many years the store operated on Main Street. A&P, as it was sometimes known, relocated for a while to the site where the current Dollar General sits, then it relocated again to where the Bo's Food Store is today. In September 1993, Bo's Food Store purchased the tea company. The A&P is shown in the background of this photograph; the gentleman is unidentified. (Courtesy of Louise McDiarmid.)

CHATTER BOX, 1949. In 1949, Avery, June, and Dale Connell—ages 16, 14, and 12—started the Chatterbox, a drive-in restaurant that became a hub of social life in Raeford and left a legacy that is still apparent many years later. The three children, along with I. W. Kinlaw, erected a small building. Here they sold 15¢ hamburgers and 25¢ shakes. After the movies, everyone gathered at the Chatterbox.

R. L. CARTER AND GRANDDAUGHTER.
R. L. Carter is pictured in his backyard
with his granddaughter Laura
Lowder. The house was located on
South Main Street where a certified
public accountant's office is today.
Carter operated a gas station at the
intersection of Main Street and
Harris Avenue for many years.

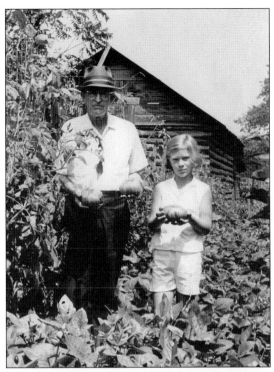

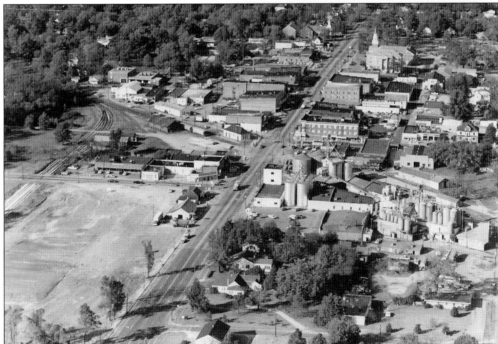

RAEFORD MAIN STREET, LOOKING NORTH. This aerial view of Raeford, looking north, shows the
Harris Avenue intersection. At the first street to the right is Upchurch Milling Company. At the
intersection to the left is Carter's Esso Service Station, and down the street is Hotel Raeford on
the right. Several of these businesses have been removed, including Hotel Raeford.

LUNDY'S SHOE SHOP. Winnie P. Lundy is photographed repairing shoes. She and her husband, A. J. Lundy, ran a shoe repair shop on West Elwood Avenue in Raeford. The expert repairers kept many people in their shoes, especially during World War II. After Winnie Lundy's death in 1988, the business closed.

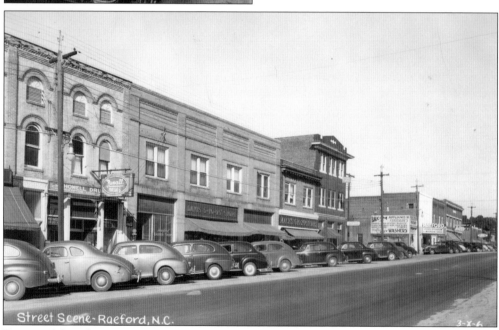

Street Scene-Raeford, N.C.

RAEFORD MAIN STREET, LOOKING WEST, 1947. In this photograph, looking west from downtown Raeford, the three-story Page building can be seen. Other buildings are the Raeford Theater (the marquee reads, "*Foxes of Harrow* with Maureen O'Hara"), Baucom Appliance Company, Mack's 5-10-25¢ Store, Davis 5-10-25¢ Store, Raeford Barbershop, and Rexall Drugs, which is now Howell Drug Company.

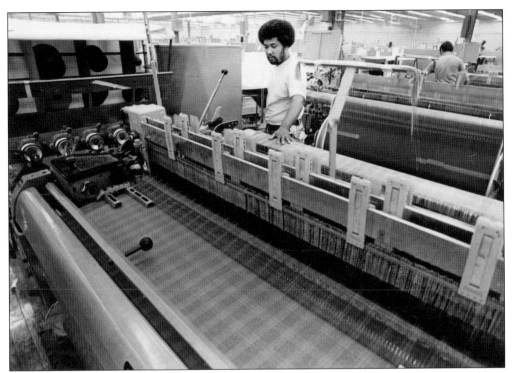

BURLINGTON INDUSTRIES, 1951. Raeford Worsted Plant (now called Burlington Industries) was constructed by Robbins Mills and began operations in April 1951. The plant endured a series of ownerships from 1951 until Burlington Industries acquired it in June 1956. In 1955, a worsted dye house was added to the large modern textile plant, making the company the largest wool fiber dye house in the world. Approximately 1,400 workers were employed there at that time. Today the plant is operating on a smaller level, but it is still one of the largest industries in the area. Pictured are the shuttles weaving units inside the plant.

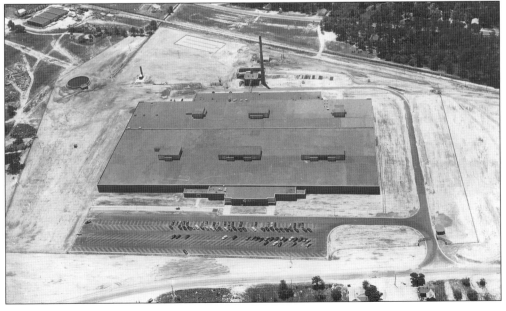

AMERICAN LEGION OFFICERS, 1959. The following men were installed as officers of the American Legion in 1959. From left to right are (first row) Bion Brewer, Comdr. Arch Sander, and Kermit Wood; (second row) Bud Williams, Graham Monroe, Harry Greene, Angus Currie, and Robert Gatlin. (Courtesy of Kermit Wood Jr.)

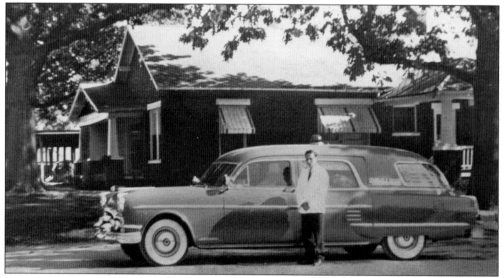

CRUMPLER FUNERAL HOME, 1960. Frank and Dayne Crumpler came to Raeford in 1960 and established Crumpler Funeral Home on Harris Avenue. A chapel was built next door a few years later. The funeral home is still in operation in 2010 with the Crumplers' son Kel and other family members running the business while Dayne and Frank enjoy retirement.

**NORTH CAROLINA FOLK HERITAGE
AWARD.** Smith McInnis was a recipient
of the 1998 Folk Heritage Award
for sustaining the state's rich folk
traditions and providing a cultural
legacy for future generations. He was
born and raised in Hoke County
in a farmhouse built by his great-
grandfather Angus McInnis. Smith
learned to play the harmonica while
his brother played dance tunes on
the fiddle. Smith took up the fiddle
at age 16 and began performing at
square dances held in neighbors'
homes or tobacco pack houses.
(Courtesy of Mary McInnis Posey.)

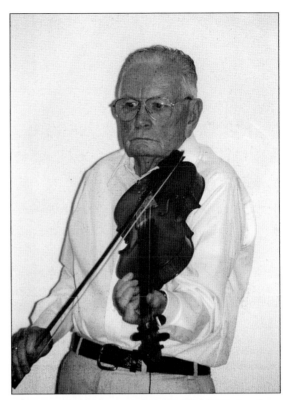

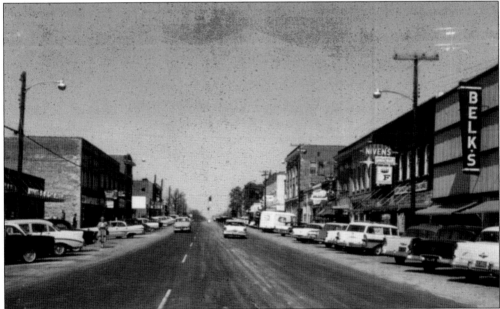

RAEFORD'S MAIN STREET, 1979. This photograph of Main Street, looking north, is an indicator
of the change in industry in Raeford. Belk, Niven's Appliance Store, McLauchlin Company, and
many other stores have changed locations or closed. Belk relocated, Niven's Appliance Store closed,
and the Bank of Raeford (now Branch Banking and Trust Company) moved to South Main Street.
(Courtesy of North Carolina Collection, University of North Carolina Library at Chapel.)

RAEFORD WOMAN'S CLUB, 1924. For the past four decades, the goals of the Raeford Woman's Club have been to promote cultural and civic betterment. The club has been a vital force in the cultural growth of Raeford and Hoke County. Pictured are, from left to right (first row) Agnes Johnson, Ina Bethune, Florrie Cameron, Sallie Brandon, Dixie McLeod, and Pearl McLeod; (second row) Beulah McNeill, Alice Upchurch, Mayme McKeithan, Katie Stevens, Frances McGoogan, and Beatrice McLauchlin; (third row) Beaulah Whitley, Madge Murray, Agnes Freeman, Kate Blue Covington, and Swannie McBryde.

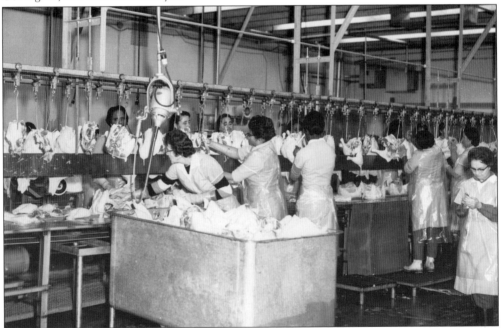

HOUSE OF RAEFORD, INC. The House of Raeford Farms, Inc., opened as a frozen food locker in 1945. Home freezers replaced the need for food lockers, and the plant moved to total turkey processing. E. Marvin Johnson purchased Raeford Turkey Farms, Inc., and changed the name to House of Raeford Farms, Inc., in 1974. The packing line pictured is preparing turkeys to be shipped worldwide. (Courtesy of House of Raeford Farms, Inc.)

OLDEST SOUTHERN WOMEN'S ORGANIZATION, 1894. Organized in 1894, the United Daughters of the Confederacy is one of the country's oldest women's organizations. Its objectives are benevolence, education, history, and patriotism. Pictured are the Raeford chapter officers for 1987 and 1988. From left to right are Lillian Wood, historian; Aline Wright, treasurer; Ruby Penny, secretary; Treva Koonce, vice president; and Isabel McFadyen, president. (Courtesy of Ellen K. Parker.)

FUN AND FELLOWSHIP. In 1995, Ruby B. Conoly invited friends to her home for a time of fun, fellowship, and sharing memories. Pictured are, from left to right, (seated) Cleva Newton and Rosa Gulledge; (standing) Ruby B. Conoly, Ann N. Webb, Susie Davis, Ollie Augustoni, Mecie Posey, Lillian Wade, and Kate McInnis.

JAMES PETERKIN SR., RADIO ANNOUNCER. James Peterkin Sr., father of county sheriff Hubert Peterkin, is pictured here talking to elder Louise K. Thomas, who was a local preacher. Peterkin announced on the radio for 60 years. (Courtesy of Ellen McNeill.)

CITY OF RAEFORD FIRE CHIEF. The Raeford volunteer fire department was organized in 1925 after a disastrous fire almost wiped out the downtown area. Robert Gatlin, pictured right, was fire chief for many years. With him is J. D. McMillan, who succeeded him as chief.

Four

EARLY CHURCHES

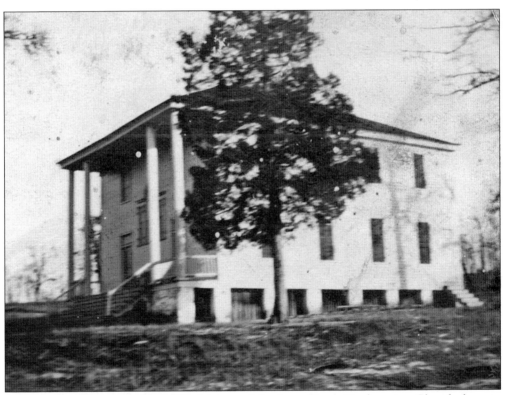

LONG STREET CHURCH, 1756. The history of the Long Street Presbyterian Church dates to January 28, 1756. Rev. Hugh McAden visited with Alexander McKay, introduced himself, and asked for a night's lodging and the opportunity to preach to the local residents. The church closed in 1923 after the area was taken over by the federal government for use as Fort Bragg. The Long Street Presbyterian Church is included on the National Register of Historic Places. (Courtesy of Raeford-Hoke Museum.)

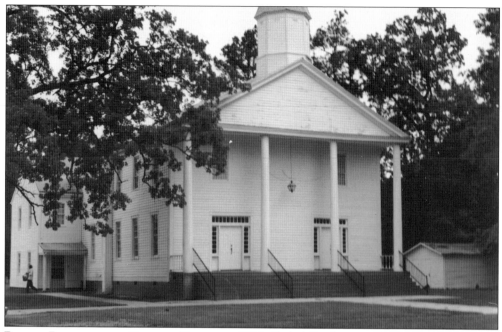

BETHEL PRESBYTERIAN CHURCH, FOUNDED 1776. Bethel Presbyterian Church was built in a Greek Revival temple form and was the third church for the congregation. Church records were destroyed in a fire in 1823. Gen. William T. Sherman's troops camped in the church from March 9 to 11, 1865, during the ministry of the Reverend Hector McNeill, and Sherman left him notes to preach about. Bethel is the oldest Presbyterian church in Hoke County today, founded in 1776. (Courtesy of Joyce Monroe.)

SANDY GROVE PRESBYTERIAN CHURCH. In 1855, Sandy Grove Presbyterian Church was organized as an outgrowth of Long Street Presbyterian Church. The first services were preached in homes, but in 1852 funds were raised to build a church. The presbytery was petitioned in 1854 with only 20 members. The first elders were Peter Monroe, Archibald McLeod, and John L. Campbell. The army purchased the land and maintains the Sandy Grove Presbyterian Church and cemetery today. (Courtesy of Raeford-Hoke Museum.)

GALATIA PRESBYTERIAN CHURCH, 1825. The first Galatia Presbyterian Church was referred to as the "shelter" and was built between 1825 and 1830. In 1859, it was rebuilt as the church in this photograph. The building was used until it was destroyed by fire in 1959. A handsome new structure was completed in 1960 and is located on the edge of Cumberland County just across the Hoke County line. Many Hoke County citizens attend this beautiful church. (Courtesy of Ellen K. Parker.)

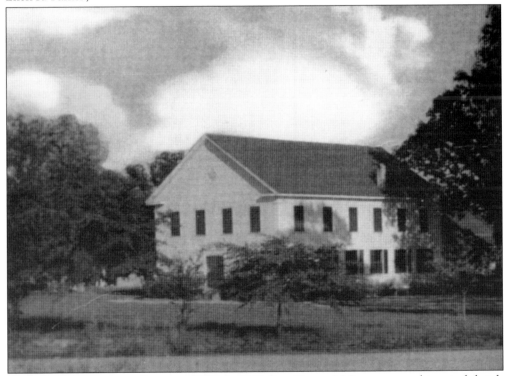

ANTIOCH PRESBYTERIAN CHURCH, 1869. In 1869, Rev. Hector McLean wrote a historical sketch that Antioch Church grew from the Old Raft Swamp Church. There was no building, so services were conducted in the grove. A building was erected and organized in May 1833. It is in a splendid state of preservation and is considered one of the most beautiful churches in the area. (Courtesy of Joyce Monroe.)

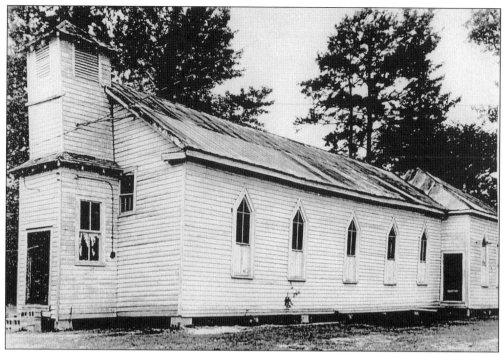

SHADY GROVE MISSIONARY BAPTIST CHURCH, 1919. Shady Grove Missionary Baptist Church began in a brush arbor in 1919 under the leadership of the Reverend T. H. Hall. The church, which consisted of only 19 members, was located just 2 miles north of Wagram, North Carolina. A new brick structure was built in 1976 on U.S. Highway 401 South, 7 miles south of Raeford. Renovations were done in 1994 with more than 6,400 square feet of usable space. (Courtesy of Connie F. Ellis.)

PHILIPPI PRESBYTERIAN CHURCH, 1800. Alan McCaskill (1800–1860) was the donor of the land on which the Philippi Presbyterian Church and cemetery are located. The Reverend Archie McQueen began to preach, once a month, under a grove of trees in the graveyard. In January 1887, a congregational meeting was held and it was unanimously resolved that a church should be built. Rev. David Fairley had a large part in the organization of Philippi Presbyterian Church. (Courtesy of Joyce Monroe.)

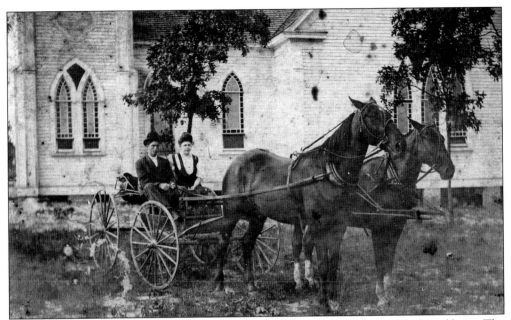

Travel to Church. Settlers built churches and communities grew around faith and hope. The church was the center of all activities and travel was by buggy, wagon, horseback, or walking. The church was used for community activities and sometimes for school.

Mount Pisgah Missionary Baptist Church, 1899. The Reverend Anderson McNeill founded Mount Pisgah Missionary Baptist Church in the early 1900s in what was known as the Seventy-First Community when there were no African American churches. Some African Americans attended worship at Galatia Presbyterian Church until Reverend McNeill built the first structure, called "Brush Harbor." Under the leadership of Reverend McDonald, the stucco edifice was built in 1956. (Courtesy of Ellen McNeill.)

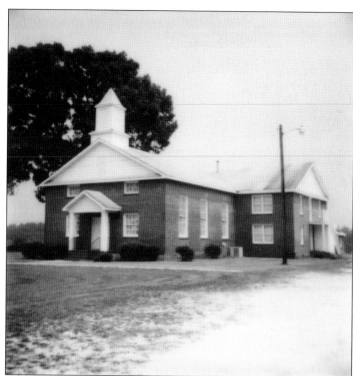

TABERNACLE BAPTIST CHURCH, 1896. In 1896, the Reverend M. A. Monroe served as moderator of the newly organized Piney Grove Baptist Church, which Rev. J. T. Townsend, Wesley White, and Alexander McDougald helped build. In 1901, the church was moved to Rockfish on land donated by May Ann Haywood Townsend, and the name was changed to Tabernacle Baptist Church. (Courtesy of Joyce Monroe.)

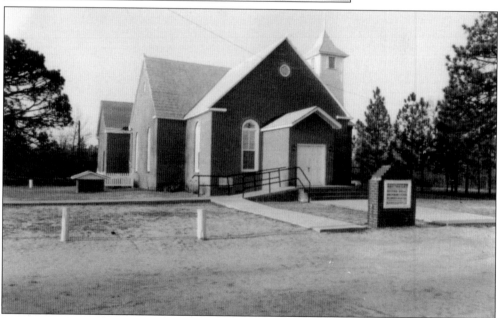

BUFFALO SPRINGS MISSIONARY BAPTIST CHURCH, 1912. This church is more than 124 years old and is located at the intersection of Turnpike and Gainey Roads. This church was built on land donated by Dora Leslie near a spring called Buffalo Creek, hence the church was named Buffalo Springs Missionary Baptist Church. The church was founded in 1912 and rebuilt in 1976. At the present time, the minister is the Reverend Yulla P. Hines and the pastor is Dr. Barry O. Shoffner. (Courtesy of Connie F. Ellis.)

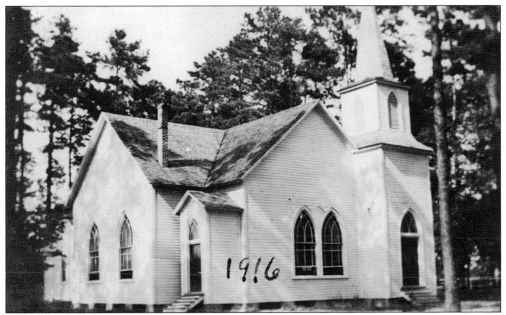

RAEFORD PRESBYTERIAN CHURCH, 1899. Raeford Presbyterian Church was organized June 27, 1899, when 31 men and women asked the presbytery for a new church. The church came into existence with Bethel Presbyterian Church having the right to be called the "Mother Church," since 27 of the 31 charter members presented letters from Bethel Church. Raeford Presbyterian Church members held services in the Raeford Institute until their new facility could be built. Two years ago the church added a new fellowship hall named John Ropp Hall, honoring a minister who served the church for 20 years. (Courtesy of Raeford-Hoke Museum.)

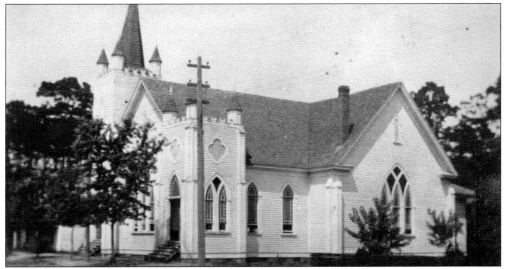

RAEFORD UNITED METHODIST CHURCH, 1900. The Raeford United Methodist Church was founded in 1900 with 14 members. The first pastor, Rev. Erskine Pope, traveled to Raeford from Red Springs and held services in the old Presbyterian church. In 1902, a building committee was formed and a labor contract was awarded to M. W. Dew for $570. Construction was completed in 1905. The church, pictured here, was destroyed by fire on December 26, 1946. After rebuilding, membership at Raeford United Methodist Church was 557 in 2010. (Courtesy of Raeford-Hoke Museum.)

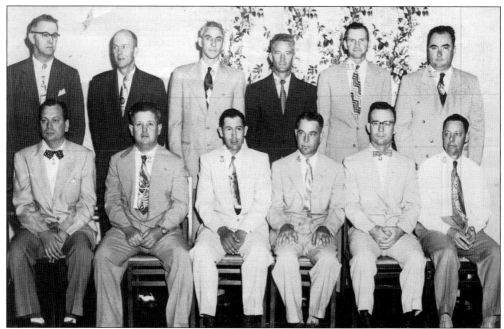

JUNIOR BOARD OF STEWARDS, METHODIST CHURCH, 1953. This photograph of the junior board of stewards was taken on May 17, 1953. From left to right are (first row) William L. Howell Jr., Walter Parks, Reid Childress (chairman), Henry C. Maxwell, Willie M. Jones, and John T. Haire; (second row) Hinson Walters, Richard A. Norris, Charlie Morrison, Neil Senter, Paul B. Livingston, and Irvine Currie.

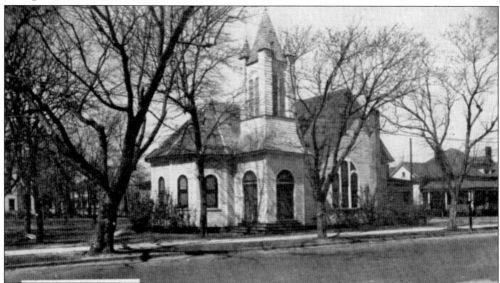

FIRST BAPTIST CHURCH, 1899. The First Baptist Church was formed in 1899 with 28 members. A site for the new church at the intersection of Highway 211 and Old Maxton Road was called Moore's Chapel, honoring Robert Alexander Moore who initiated the church. The church was moved to Raeford in 1904 and the name was changed to Raeford Baptist Church; it is now called First Baptist Church. There have been 21 ministers, and presently the membership is at 300. (Courtesy of Raeford-Hoke Museum.)

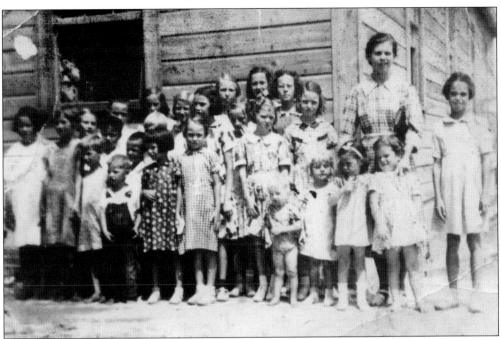

EVANGELICAL METHODIST CHURCH. Mrs. J. L. McLeod was the first founder of the Evangelical Church of Raeford, North Carolina. Pictured is the first Sunday school class at People Methodist Church, taken in 1938. Sarah Davis was the Sunday school teacher. The name of the church was later changed to Evangelical Methodist Church. On September 25, 2006, Raeford Evangelical Methodist Church had a dedication service for a new building located on Palmer Street. (Courtesy of Elizabeth Webb.)

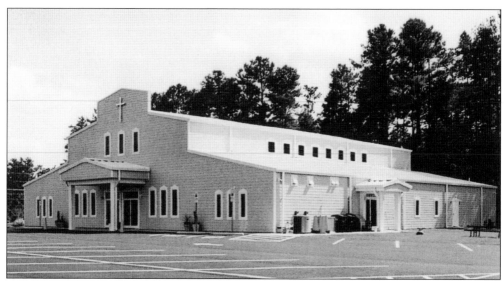

St. Elizabeth of Hungary, 1958. Property was purchased in Raeford for a Catholic Church in 1958. With the help of Genevieve M. Carter, Sure M. Gorman, Marion C. D'Agostine, and Teresa A. Conlin, work began on the chapel. It was named St. Elizabeth of Hungary in memory of the mother of Walter J. Black and sister Jeanne Morgan. The church is 51 years old. They now have a new facility located off U.S. Highway 401. (Courtesy of Connie F. Ellis.)

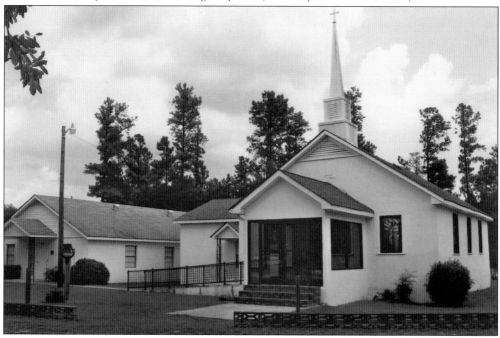

Community United Methodist Church. This neighborhood held prayer meetings in the Five Points community under the leadership of Mildred Martin Ellis for five years before the church was formed. The next "church" venue was a small tenant house on the property of R. L. Chambers, with the Reverend W. L. Maness preaching. Community United Methodist Church was organized on October 12, 1947. The total annual budget at the first conference was $296.75, including the pastor's salary. (Courtesy of Connie F. Ellis.)

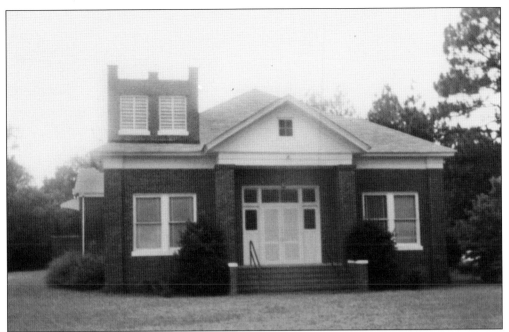

SHILOH PRESBYTERIAN CHURCH, 1889. In the early 1880s, the Reverend Andrew McMillan preached in a store building near the Old Shiloh Church. Later a Sunday school was organized and preaching was held in the schoolhouse. As the Sunday school grew, there was a demand for a church. Shiloh Presbyterian Church opened its doors on September 14, 1889. (Courtesy of Joyce C. Monroe.)

SANDY GROVE UNITED METHODIST CHURCH, 1881. This church took its name after Sandy Run, a part of Hoke County that was given that name because stagecoaches would often get bogged down in this sandy part of the Great Northern and Southern Stagecoach Line, which ran between New York and New Orleans. The original church started in 1881 and was remodeled in 1999 to include a day care facility and a place to provide meals for seniors. (Courtesy of Joyce C. Monroe.)

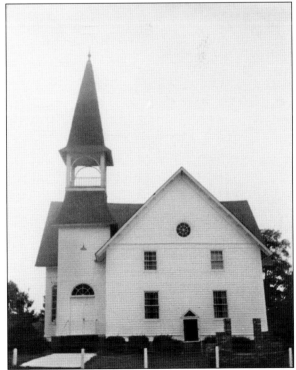

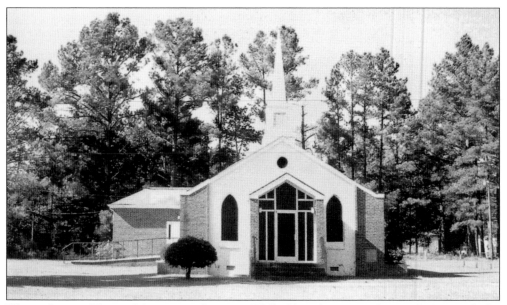

WALLS CHAPEL UNITED METHODIST CHURCH. Walls Chapel originated around 1874, with the church beginning underneath a large tree. Some of the men in the community constructed the first wooden building to serve as a church. In 1953, a cinder block church was built. After the demolition of the Bowmore School in 1956, the cafeteria was left standing. The Walls Chapel United Methodist Church purchased the cafeteria and the land, which is now used as a fellowship hall. (Courtesy of Elena Southerland.)

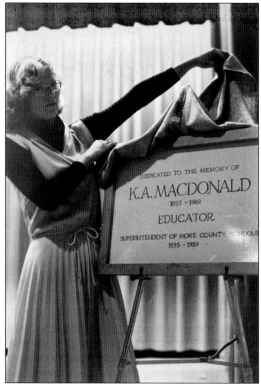

K. A. MacDONALD SCHOOL. Pictured is Ann MacDonald, granddaughter of K. A. MacDonald, as she unveils a plaque in honor of her grandfather. MacDonald was honored for serving the students of Hoke County as their superintendent from 1935 to 1959. Under his leadership, several things improved at the schools, such as attendance, transportation, buildings, and student health. The new school building was named in his honor.

Five

EDUCATION AND SPORTS

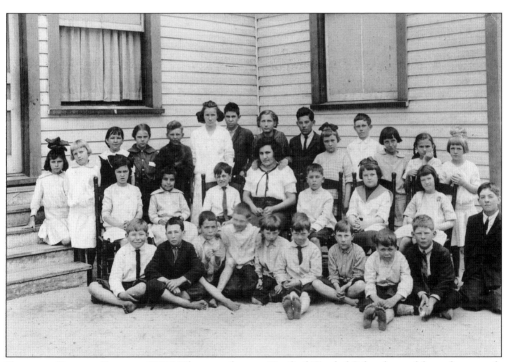

RAEFORD GRADED SCHOOL, 1916. These students at Raeford Graded School posed for a photograph with their teacher, Irene Parks, in 1916. Some children who may be in this picture are, in no particular order, Neill Currie, Mercer Covington, Lawrence McNeill, Roy Baker, Alex Walters, Lenious Moore, Carlyle Townsend, Malcolm McBryde, Herman Campbell, Glenn Peele, Graham Colbert, Neill McDonald, Alton Cameron, Lawrence Conoly, Willie Walters, Madge Yoemans, Isabel J. Lamont, Nellie Rye, Martha Lee McLean, Gladys Price, Marie Dew, Lilly Lockey, Mary Blue, Eula Blue, Lois McDonald, Flora McPhail, Eunice Baker, Sarah McEachern, Lillian Akins, Pauline Freeman, and Addie Gatlin. (Courtesy of Raeford-Hake Museum.)

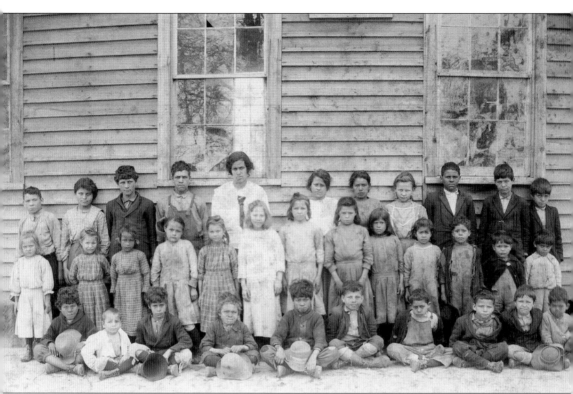

HOKE COUNTY NATIVE AMERICAN SCHOOLS. Information surrounding the Native American schools of Hoke County consists of few facts. Jacobs Point is the first Native American school mentioned in the Hoke County Board of Education minutes from August 19, 1914. Further reading of minutes indicates the school came into existence while Antioch Township was still part of Robeson County. Elisah Dial and Rodney Locklear were the main forces behind the establishment of a school that would serve the Native American population of Hoke County. Jacobs Point was a one-room school, which operated until 1934 when a new two-room school was built, named the Antioch Indian School. Macedonia School is another one-room school mentioned in the minutes, but information about it is very limited. According to an article in the *News-Journal* dated September 3, 1953, Macedonia School antedated another school that burned in 1933. Pictured are students from a Native American one-room schoolhouse. (Courtesy of Raeford-Hoke Museum.)

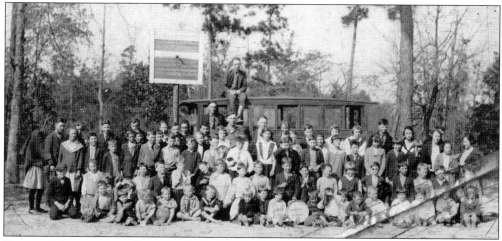

ROCKFISH ELEMENTARY SCHOOL, 1904. In 1900, the children in the Rockfish area were part of the Galatia School District, and they walked to school. At the parents' request, a one-room schoolhouse was built in Rockfish so students would not have to walk so far. In 1924, a new school was built, and Pine Forest and Harmon were consolidated with Rockfish. About this time, the first school transportation was used in McLauchlin Township. In the background of this photograph is a school truck. (Courtesy of Alma Lee Simpson.)

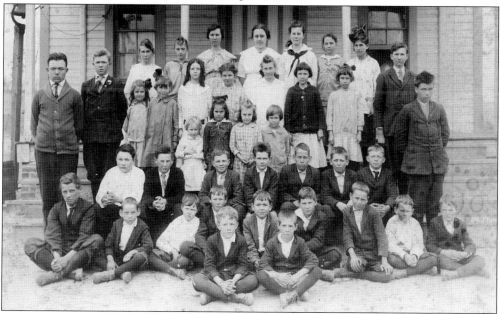

MONTROSE STUDENTS, 1917. These youthful children posing outside the 67-year-old Hoke County School building are students from the Montrose School. They are Lee Maultsby, James Riley, Walter Livingston, Graham Smith, Jack Clark, Albert Perdue, Clay Riley, Joe Clark, Howard McAnulty, Howard Usher, Kathleen Seaford, Addie B. Hardister, Edith Seaford, Gladys Usher, Ruth Usher, Ina Seaford, Morsel Thompson, Mary Smith, Pearl Smith, Ida Tapp, Monroe, Chapple, Wall Covenington, Margaret Livensting, Juanita Perdue, Rosada McAnulty, Fay Clark, Never Jenkins, Marie McFadyen, Hattie Thompson, Luther Tapp. Alex Petterson, Allen Usher, Virgil Clark, John Maultsby, Earl Riley, Frank Riley, and Alford Covering. Sadie McBrayer (pictured top center) was the teacher. (Courtesy of Raeford-Hoke Museum.)

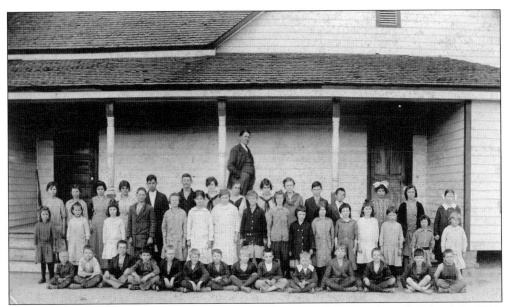

Dundarrach School, 1911. Students are posing in front of the Dundarrach School. In 1911, Martin Archibald Patterson, father of administrator Alex M. Patterson, taught in this school. Tom Hall and Jesse Gibson requested a third teacher on January 1, 1922. It was approved if a teacher could be found for $45 a month. In March 1922, the school was consolidated with Arabia to become Mildouson Elementary School. (Courtesy of Raeford-Hoke Museum.)

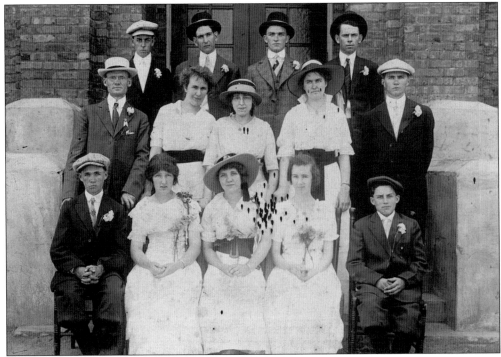

Antioch School, Graduating Class. The date of this graduation is uncertain, but the student on the back row, second from right, is David H. Hodgin, who served as Hoke County sheriff from 1926 to 1962. (Courtesy of Raeford-Hoke Museum.)

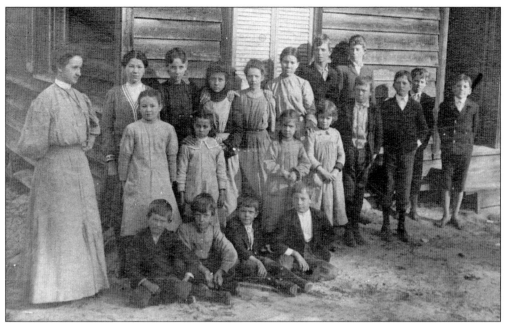

BETHEL TEACHERAGE, SPRING BRANCH. Bethel Teacherage was on McQueen family land, same as Spring Branch built about 1925. Before the school was built, the students attended Spring Branch, which was known as the "Rolling Academy" because its location changed so often. Lettie McMillan taught there from 1932 to 1934. J. A. McGoogan, the first school superintendent in Hoke County, signed her teacher's certificate in 1911. McMillan is pictured here with her class. (Courtesy of Raeford-Hoke Museum.)

WHITE OAK SCHOOL, 1900. The history of this school goes back to the early 1900s when it was located on what is now U.S. Highway 401. It was moved to the Pittman Road site in the 1920s and African American residents levied a special tax on themselves to support it. It closed in 1960. A monument bears the name of the last principal, John D. McAllister, and teachers Hannah and Leona Coleman. (Courtesy of Raeford-Hoke Museum.)

ASHEMONT SCHOOL, 1930. Pictured here is the eighth grade class of Ashemont School in 1930. The students are W. P. Rodgus, Margaret Hodgin, Myrtice Barrington, Treva Aulmond, Thelma Almond, and Mary Dunlap. (Courtesy of Raeford-Hoke Museum.)

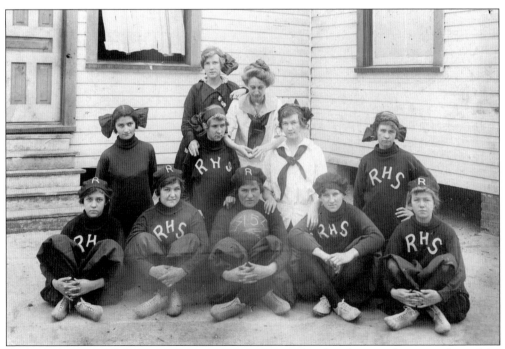

RAEFORD HIGH SCHOOL BASKETBALL, 1915–1916. Pictured in this photograph are members of the Raeford High School basketball team for the school year 1915–1916. From left to right are (first row) Bennie Lee Upchurch, Eliza M. McEachern, unidentified, Jesse Page Clark, and Mary Blue (Fuller); (second row) four unidentified; (third row) unidentified and Anna McDonald (Covington).

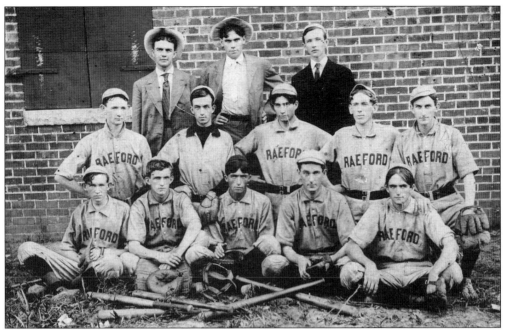

RAEFORD BASEBALL TEAM, 1910 OR 1915. Baseball was a game that became quite popular in the early 19th century. From left to right are (first row) Julian Johnson, Lawrence Poole, Martin McKeithan, Luke Bethune, and Dan McKeithan; (second row) Scott Currie, Frank Blue, Make McKeithan, Hallie Gatlin, and Will McLean; (third row) coach Easley, Oscar Williamson, and Fred Johnson. (Courtesy of Raeford-Hoke Museum.)

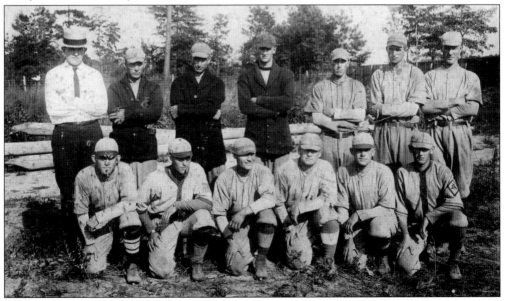

BASEBALL TEAM PLAYERS FOR RAEFORD. Baseball is an American tradition rich in legends, where every game is a nine-inning chapter and where it's never over til it's over. From left to right are (first row) Buck Blue, Alfred Cole, unidentified, Clyde Upchurch Sr., unidentified, and Scott Currie; (second row) unidentified coach, Raymond McLean, Make McKeithan, John Walker, unidentified, Dan McKeithan, and Marshall Davis. (Courtesy of Raeford-Hoke Museum.)

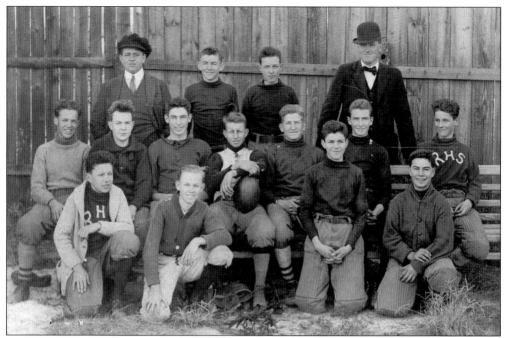

RAEFORD'S FIRST FOOTBALL TEAM, 1915. From left to right are (first row) Roy Reaves, Forrest Lockey, Ben Hassell, and Dwight Niven; (second row) David Wright, McNair Smith, Neill Cole, Love Heins, Graham Dickson, Walter Baker, and Herbert Seagrove; (third row) Lewis McBrayer, Buck Blue, John McKoy Blue and coach H. W. B. Whitley. Love Heins was the only boy on the team who had ever seen a football game. Neill Cole was the only boy on the team who had shoulder pads. (Courtesy of Raeford-Hoke Museum.)

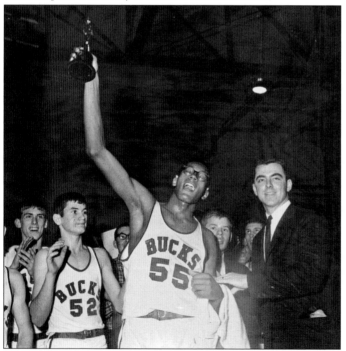

GILBERT MCGREGOR, BASKETBALL PLAYER, 1969. Gilbert McGregor, a well-know basketball player from Hoke County High School, went on to play for Wake Forest University and was the fifth leading rebounder in the school's history. He was drafted by the Chicago Royals and played one season before the franchise moved. He went on to play in France, Italy, and Ireland and later became a sports announcer for the Charlotte Hornets.

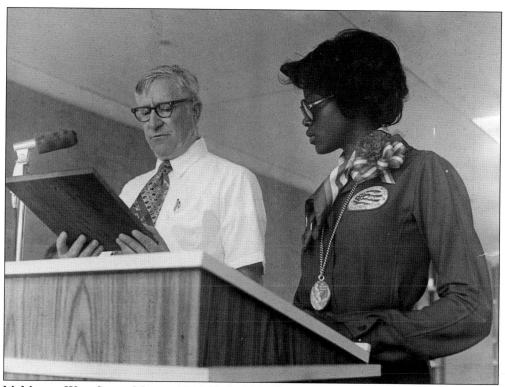

McMillan Wins Silver Medal, 1976. Kathy McMillan won a silver medal in the 1976 Montreal Olympics for the Women's Long Jump event. She had just graduated from Hoke County High School. McMillan took the American title with a national record of a 22.3-foot leap. She was named one of *Sports Illustrated*'s 50 greatest sports figures in North Carolina that year. Pictured is McMillan wearing her medal as Sam Morris reads a plaque presented to her by the City of Raeford.

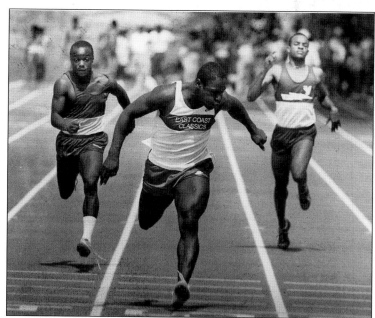

Carpenter Stars in Junior Track, 1985. Terrell Carpenter of the East Coast Classics won the 100-meter dash in a speedy 10.53 seconds. The sprint was the second time in two days that Carpenter, a rising senior at Hoke County High School, had broken the national Junior Olympics record. Carpenter also won the long jump with a leap of 23 feet, 8.5 inches. (Courtesy of Terrell Carpenter.)

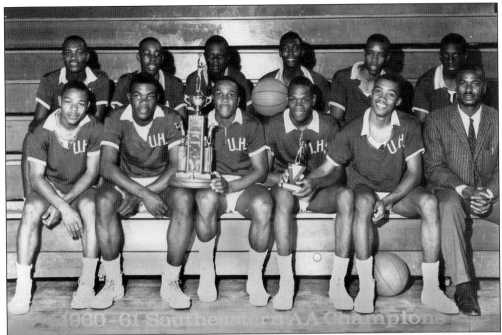

UPCHURCH HIGH SCHOOL EAGLES, 1961. The Upchurch High School Eagles boys' basketball team won the title for the 2A Southwestern District Championship and a second trophy for their sportsmanship in 1961. Pictured from left to right are (first row) John Morrison, Tim McKoy, James Gay, Henry Blue, Clarence Ross, and coach Wilson McDowell; (second row) Robert Blue, Steven Swann, Lingle Morrison, Harvey Adams, James Roper, and Jerome Bratcher. Henry Maynor is not pictured. (Courtesy of Elvenia Southerland.)

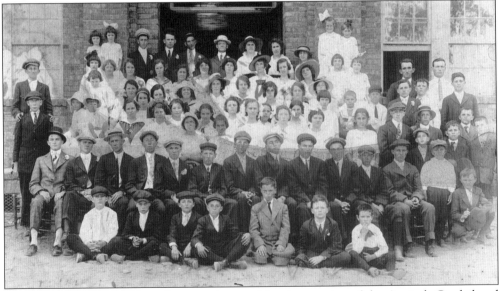

ANTIOCH GRADED AND HIGH SCHOOL. Approval for the opening of the Antioch Graded and High School was granted in 1911. The date of this school photograph is unknown, and the only students identified are Dave Hodgin, seated in the first row at the left, and Lillian McPhaul, standing in the fifth row, fourth from the left.

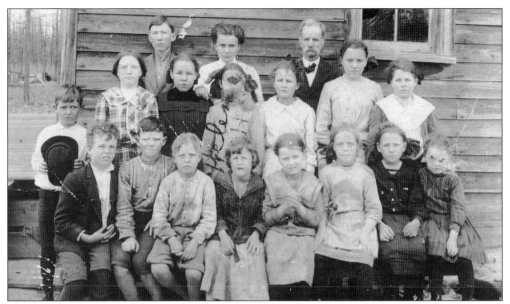

WILD WEST SCHOOL STUDENT, 1906–1907. A one-room schoolhouse was located on Rockfish Road. Pictured from left to right are (first row) Pat Monroe, unidentified, Lock Guin, Clara Wood, Lena Koonce, Curtis Wood, Nancy Rene Bradshaw, and Ollie Moore; (second row) unidentified, Ethel Gillis, Ruth Willis, Helen Townsend, Beulah Cheek, Maggie Moore, and Ada Gillis; (third row) Percy English, Eunice Raye, and teacher Archie Monroe. (Courtesy of Margaret Willis English.)

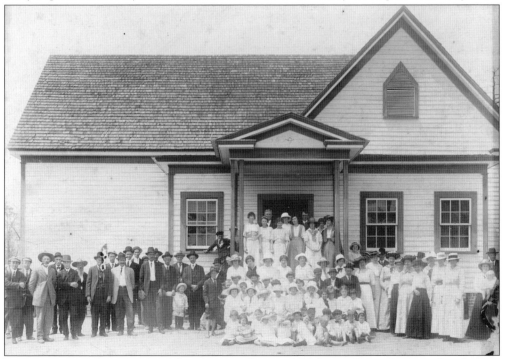

BETHEL SCHOOL GRADUATION. This photograph was taken during the graduation of students at the Bethel School in Hoke County. Everyone is dressed for the special day. The people pictured are unidentified.

UPCHURCH HIGH SCHOOL, CLASS OF 1962. On November 18, 1920, a school for African American students was built. Through the efforts of Willie Frierson, Ed Buie, Matthew Graham, and Jess Dunlap, Hoke County became the first county in the state to have two county-wide high schools. The school's name honors T. B. Upchurch Sr. for his donations to the construction of the school. The original building was destroyed by fire in 1944 but was rebuilt in time for the 1945 school year. (Courtesy of Ellen McNeill.)

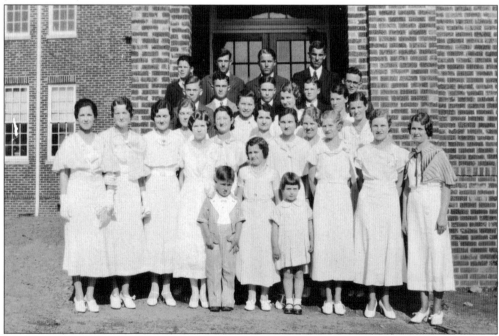

GRADUATING CLASS, HOKE COUNTY HIGH SCHOOL, 1933. There were about 25 students that graduated from Hoke County High School in 1933. The little girl that is their mascot is Patsy Blue, mother of Mike Hoffman. The photograph was taken outside the old school building that burned. J. W. McLauchlin School was built on that lot. (Courtesy of Raeford-Hoke Museum.)

HOKE HIGH MARCHING BAND. This photograph was taken during the North Carolina Turkey Festival that is held each year in Raeford on the third weekend in September. The high school marching band marches in the Red Springs, North Carolina, parade, and participates in band days where they compete for trophies. In 2009, they marched at Disney World.

FRIENDSHIP SCHOOL. Pictured is a one-room African American school, an example of the many one-room schools located around Hoke County until the schools were consolidated and improvements were made. The Friendship School closed at the end of the 1959 or 1960 school year. Two of the last teachers were Selena Pierce and Rosa Anders. (Courtesy of Raeford-Hoke Museum.)

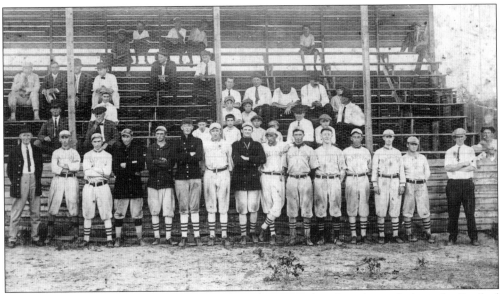

BASEBALL TEAM, 1915. The baseball park where this team played was located where the Raeford Cemetery is now. Pictured from left to right are Will McLauchlin, unidentified, Herbert McKeithan, Make McKeithan, Dan McKeithan, unidentified, Doc Newton, Fred Johnson, unidentified, John Walker, Julian Johnson, Martin McKeithan, Jasper Davis, Fred Blue, and unidentified.

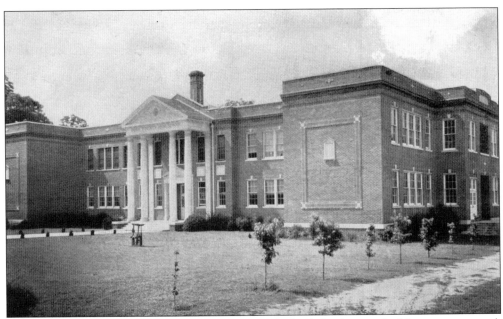

HOKE COUNTY HIGH SCHOOL. On August 31, 1934, the brick for this new building was approved; on September 23, 1935, contracts for the furniture were approved; and on October 30, 1936, the board of education approved the Hoke County High School project. Construction was done by the Works Project Administration (WPA), known by many as "We Poke Along." Today the building is known as Turlington School.

ABOUT THE ORGANIZATION

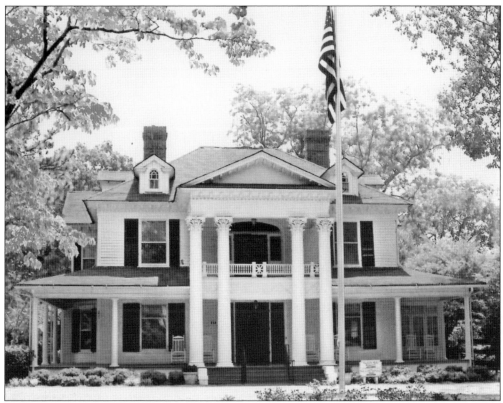

The Raeford-Hoke Museum nonprofit corporation was organized in 2001, and the McLauchlin-McFadyen house was purchased in 2002. Only two families have owned the McLauchlin-McFadyen home, which was built around 1905, but the 6,000-square-foot home has sheltered many, including teachers and traveling preachers. The mission of the museum is to collect, preserve, and document the history of Raeford and Hoke County.

www.arcadiapublishing.com

Discover books about the town where you grew up, the cities where your friends and families live, the town where your parents met, or even that retirement spot you've been dreaming about. Our Web site provides history lovers with exclusive deals, advanced notification about new titles, e-mail alerts of author events, and much more.

MADE IN THE USA

Arcadia Publishing, the leading local history publisher in the United States, is committed to making history accessible and meaningful through publishing books that celebrate and preserve the heritage of America's people and places. Consistent with our mission to preserve history on a local level, this book was printed in South Carolina on American-made paper and manufactured entirely in the United States.

This book carries the accredited Forest Stewardship Council (FSC) label and is printed on 100 percent FSC-certified paper. Products carrying the FSC label are independently certified to assure consumers that they come from forests that are managed to meet the social, economic, and ecological needs of present and future generations.

FSC
Mixed Sources
Product group from well-managed forests and other controlled sources

Cert no. SW-COC-001530
www.fsc.org
© 1996 Forest Stewardship Council

Find Your Place in History.